WATERCOLOUR
—— WORK-OUT ——

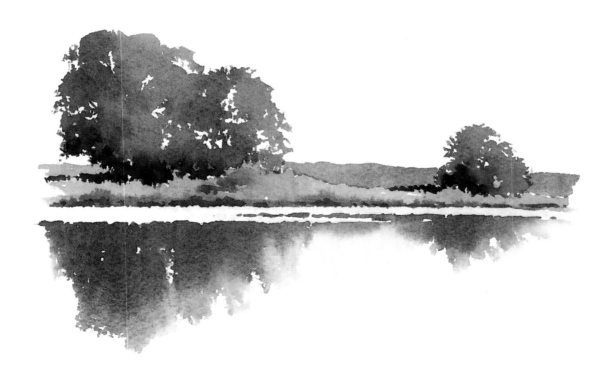

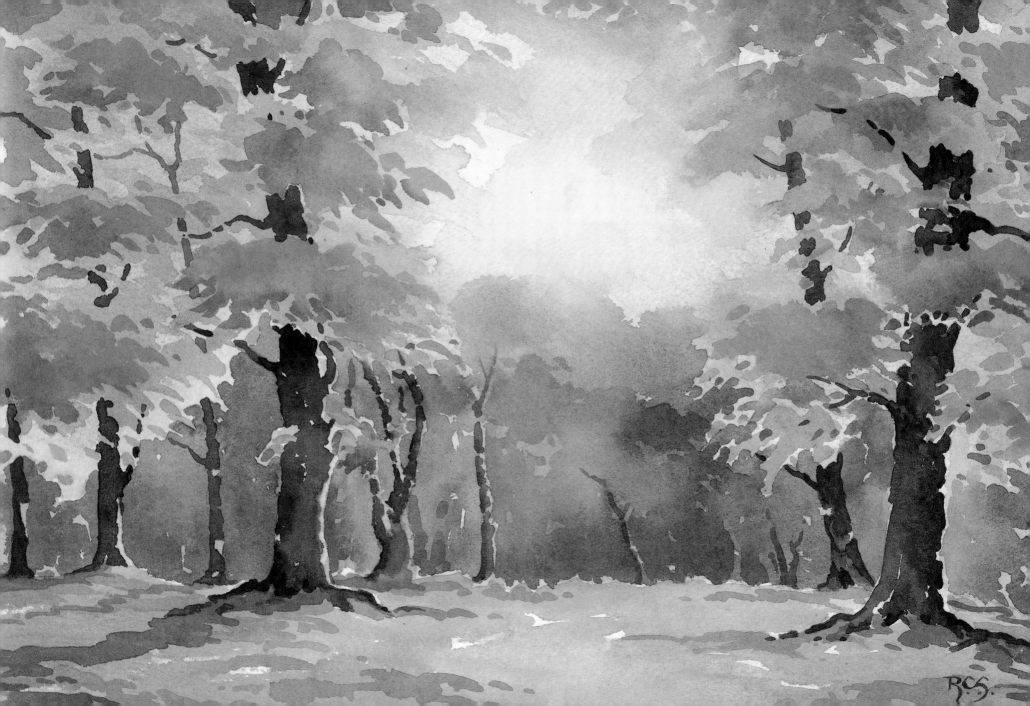

WATERCOLOUR
WORK-OUT

50 Landscape Projects
FROM CHOOSING A SCENE TO PAINTING THE PICTURE

RAY CAMPBELL SMITH

David & Charles

**To my family, my friends and all those who share my love
of pure watercolour.**

ACKNOWLEDGMENTS

I would like to thank my editor, Alison Elks, for her expert help and advice; my son Paul, M.A.
(Royal College of Art), B.Sc. (London University) for his first-rate photography; Cherry Briers,
editor of *Leisure Painter*, for kindly allowing me to use material from that splendid magazine;
Maureen Gray for her skillful typewriting, and my wife, Eileen, for her constant encouragement
and support.

A DAVID & CHARLES BOOK

First published in the UK in 1995
Reprinted 2003
First paperback edition 1999
Reprinted 2000, 2003

Copyright © Ray Campbell Smith 1995, 1999

Ray Campbell Smith has asserted his right to be identified as author of
this work in accordance with the Copyright, Designs and Patents Act, 1988.

A catalogue record for this book is available from the British Library.

ISBN 0 7153 0256 6 hardback
ISBN 0 7153 0939 0 paperback

Printed in Hong Kong by Dai Nippon
for David & Charles
Brunel House Newton Abbot Devon

CONTENTS

INTRODUCTION

As more and more people find interest and fulfilment in drawing and painting, so the volume of help and advice in book and video form expands to meet the demand. I have reviewed many dozens of books for art magazines and although most of them contain useful and expert instruction, I have yet to find one that tackles, head on, the basic problem that confronts every aspiring painter – how to begin to set about capturing the essence and the atmosphere of a chosen subject.

'Please get me started!' is an appeal every art tutor has heard many times, and if he is doing his job properly, he will guide but not take over. Inexperienced painters nearly always have a problem bridging that yawning gap between locating an appealing subject and doing something constructive about it. Even when they take their courage in both hands and get down to some preliminary sketching, this initial stage is often rushed and not given the careful, creative thought it demands. And so, instead of a personal statement that says something fresh and original about the subject, a tame and conventional layout results. Any hope that the painting process will somehow breathe life and interest into a dull arrangement is, sadly, doomed to failure, for a painting can never recover from a pedestrian composition.

Having located a subject that fires their imagination, many beginners find their hopes of saying something fresh about it begin to fade as the work progresses. That first fine, careless rapture is somehow lost along the way and they are left with just one more adequate but uninspired effort. What is it that always seems to come between their initial lively vision and the finished painting? Why is there such a gap between the original inspiration and the run-of-the-mill outcome? Such disappointments are hard to take and many painters lose heart and resign themselves to failure, believing, usually wrongly, that they just have not the necessary talent to convey their message in paint.

If you constantly suffer disappointment of

(Opposite) *River Scene*

7

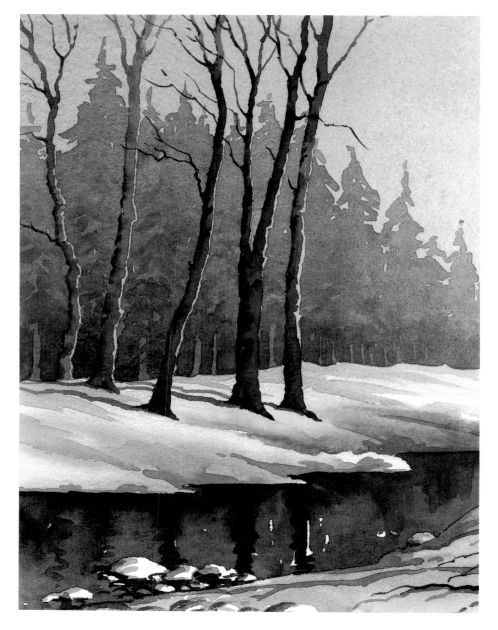

A Winter Stream
(Opposite) Autumn Walk

this sort, take heart! You *can* overcome your seemingly insuperable problem – indeed, by recognizing your own shortcomings, you are already half way there! The only real bar to progress is self-satisfaction and those who do not feel the need to correct, or even recognize, their own mistakes are unlikely to make significant improvement.

Let us now acknowledge and confront that daunting gap between inspiration and realization, analyze the problem and then work out a strategy for overcoming it. We know that what appears exciting and full of promise on the ground can end up looking flat and dull on paper, and we must ask ourselves why this happens and what is going wrong. Although difficulties seem to start as soon as we try to capture a three-dimensional subject in two dimensions, this is not the real problem. The villain of the piece is often over-anxiety to get down to the business of painting, for this denies the time and thought required for the important process of assimilation and interpretation of the subject. Far better to contain your impatience to pick up your brush and concentrate on finding a telling angle and on experimenting with different compositions.

I always make at least three rough sketches, frequently more, from different viewpoints and only then do I decide which is the most interesting and says most about the subject. This not only helps me find a promising

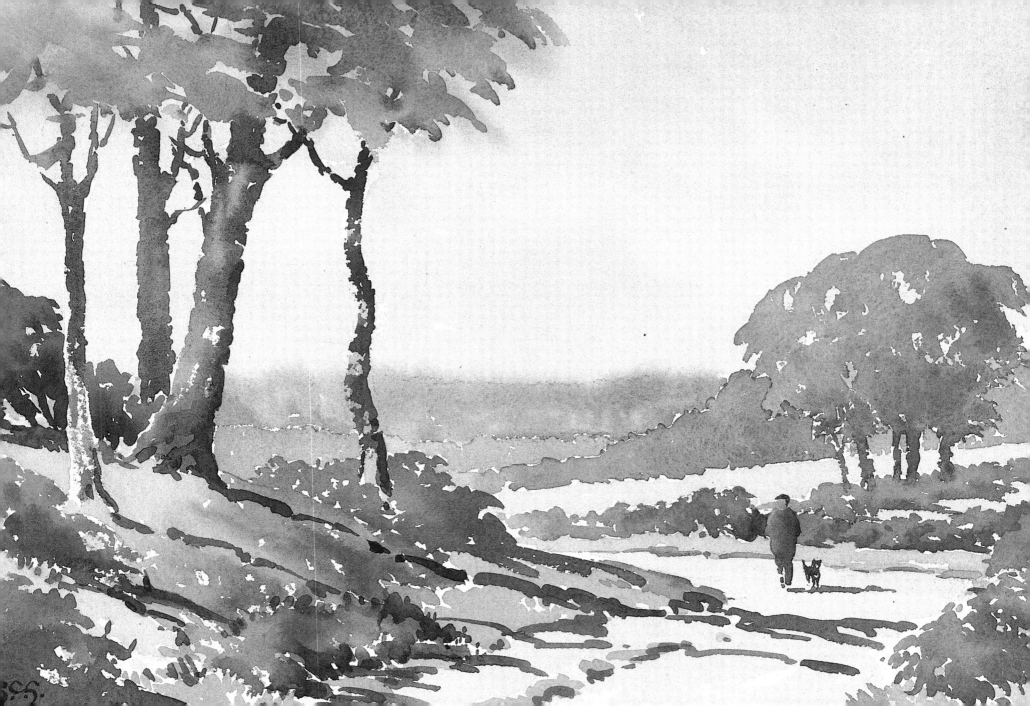

composition but also makes me look at my subject in depth and so discover more about it.

This approach is of the greatest help to the less confident who have difficulty getting started, for there is nothing inhibiting about making quick thumb-nail sketches and these help to bridge that awkward gap we have been

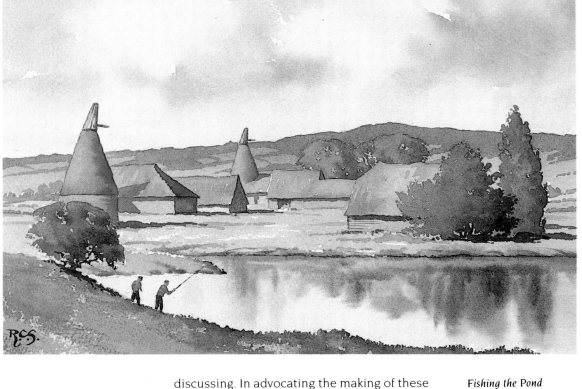

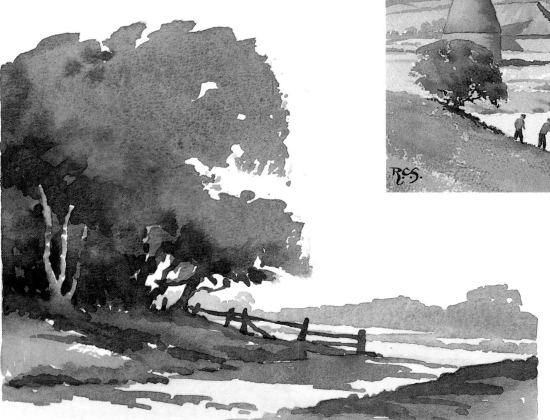

discussing. In advocating the making of these quick, exploratory sketches, I am certainly not recommending too much drawing on the water-colour paper prior to painting – a few guide lines, just sufficient to enable you to paint your chosen arrangement, are all you need. The more you can leave to expressive brushwork, the better the development of style and fluency.

Let us now assume we have examined our subject from various angles and are satisfied that we have chosen the best of our series of quick sketches. Certainly, we have made the

Fishing the Pond (Opposite) Christmas at Penshurst

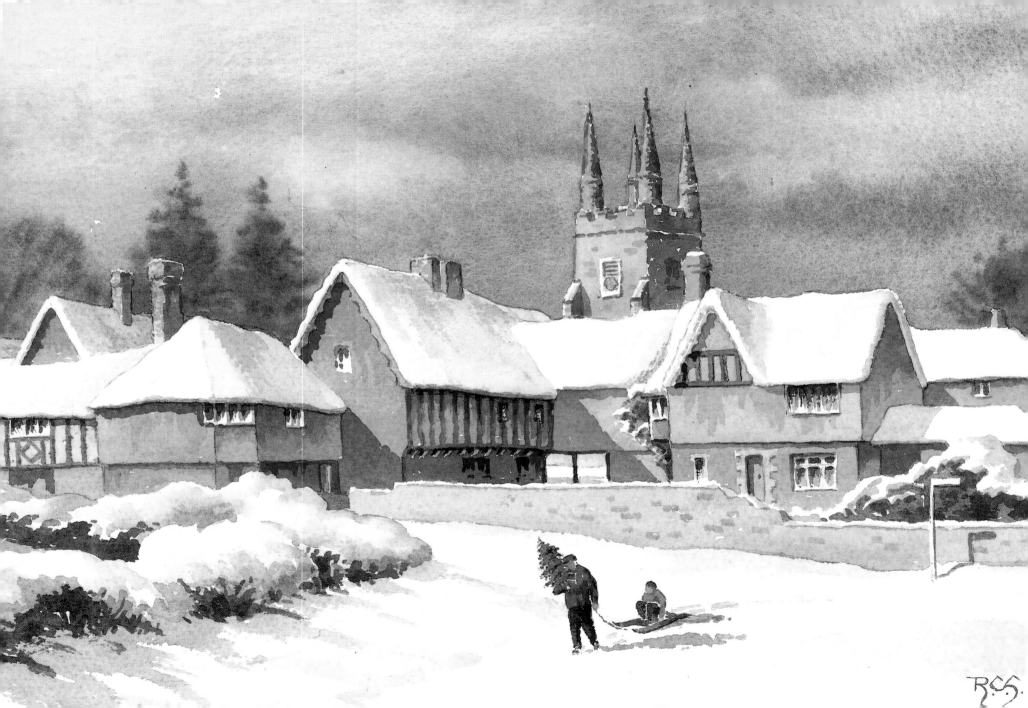

Shelley's Walk, Lechlade

right start but this does not guarantee success. The next step is to analyze both the tones and the colours of our subject before even thinking of applying paint. This is a vital step that many beginners omit altogether. They start painting before they have worked out their strategy and if they find the tone or colour, or both, of the applied pigment is wrong, they start to make corrections and alterations, thereby losing freshness and clarity at every stage. Train yourself to look at your subject in watercolour terms and make up your mind in advance what tone and colour each passage should be. If you are not sure that your washes are correct, always try them out on an offcut of watercolour paper where mistakes do not matter. Only when we apply a wash quickly and directly, without any alteration or modification, can we be sure the result will be clear and luminous.

It is not, of course, simply a matter of analyzing your subject for tone and colour – a successful watercolour painting demands far more of the artist. First you must train yourself to simplify. This is not just a question of leaving out inessential detail, important though that is. You must learn to see areas made up of many tiny objects, such as foliage, as masses, and paint them accordingly. Trees painted with thousands of minute green dots cannot fail to look laboured and unconvincing, but if you view your subject through half-closed eyes, detail disappears and you only

see masses of varying tone and colour. Much the same applies to the treatment of such material as shingle, where any attempt to paint every pebble separately would again result in gross overworking. Techniques such as dragged brushwork and the broken wash can be used to good effect to suggest such surfaces. A large brush, loaded with liquid pigment, dragged rapidly over the surface of a rough paper, will produce chains of white dots which can give the impression of a textured surface and the result will look fresh and lively. These techniques require plenty of practice, but they are well worth the effort for the spontaneous results that may be obtained. Always remember that in the watercolour medium a spontaneous result invariably looks better than a laboured one.

Successful painting demands more of us than simply recording what is there and sometimes we have to try to improve on nature, arrogant though that may sound. It frequently happens that our subject matter is lacking in tonal contrast and, painted literally, would look somewhat flat as a result. In such cases we must accentuate the difference between lights and darks so that our painting is more impactive. Always look for opportunities of placing lights against darks and vice versa, and if this means a little judicious rearrangement of the scenery, so be it.

Contrast in colour is another matter we must constantly bear in mind. The placing of complementary (or opposite) colours side by side can add life and vibrancy to our work: a figure dressed in red against a predominantly green background is just one example. Some painters are fortunate in having an instinctive feeling for colour and use it imaginatively and

Home Farm

(Opposite) *Pin Mill*

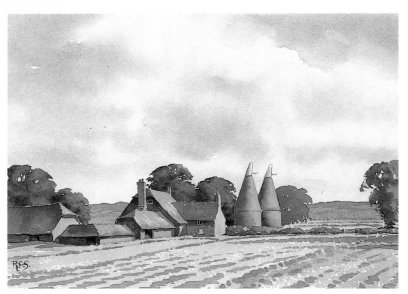

to telling effect; others have a more literal and conventional attitude and unless they make a conscious effort to develop their appreciation and understanding of colour, their paintings are inclined to look prosaic and unexciting.

Landscapes in high summer are often an unrelieved green, and if painted literally can appear uninteresting. A painter with a good colour sense will look for colours other than green and will find oranges, browns and, in the shadows, purples as well. He will not only include these and any other colours he can identify – he may also exaggerate them. Such exaggeration is entirely acceptable if it results in a glowing and vibrant painting which calls our attention to colours of which we may not have been aware.

Colour, imaginatively used, can add depth to a painting and aid recession. The water vapour and dust in the atmosphere have a greying effect on colour and that is why distant objects, viewed through a broad swathe of atmosphere, usually appear to be soft tones of grey and blue. Nearer objects, by contrast, appear much warmer in colour. On very clear days the difference in colour temperature between near and distant objects may be minimal and if the colours were painted literally, there would be virtually no feeling of recession. This is where a little artistic licence is necessary, to add soft blues and greys to the distance to make it recede.

All these matters are illustrated in the paintings reproduced in the following pages. In each double-page spread the finished watercolour appears on the right, with the

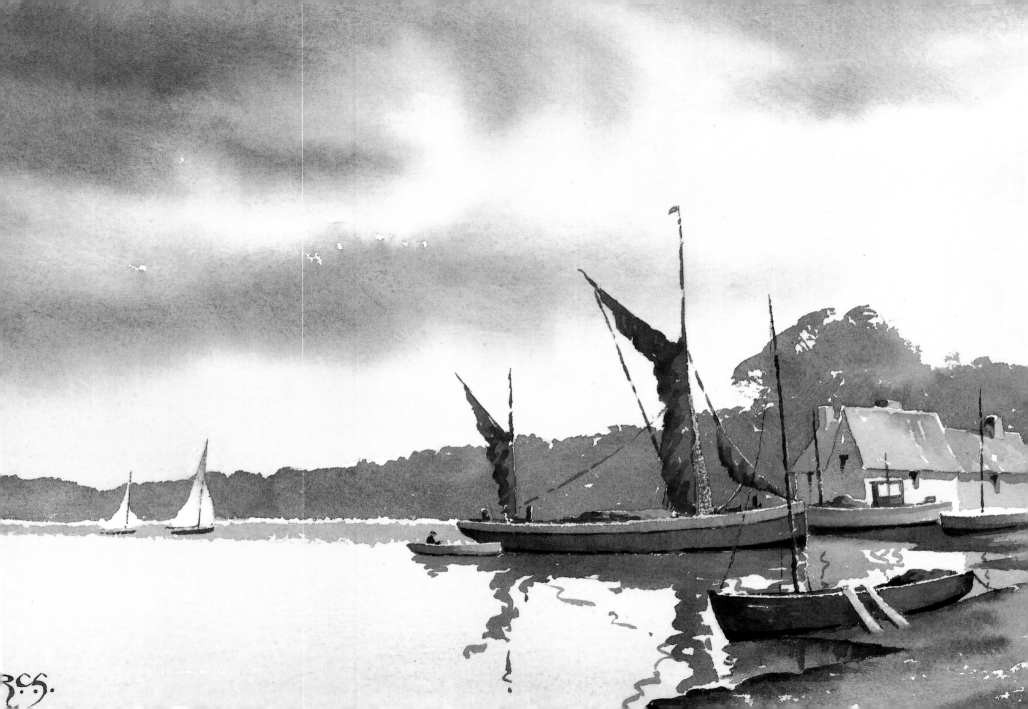

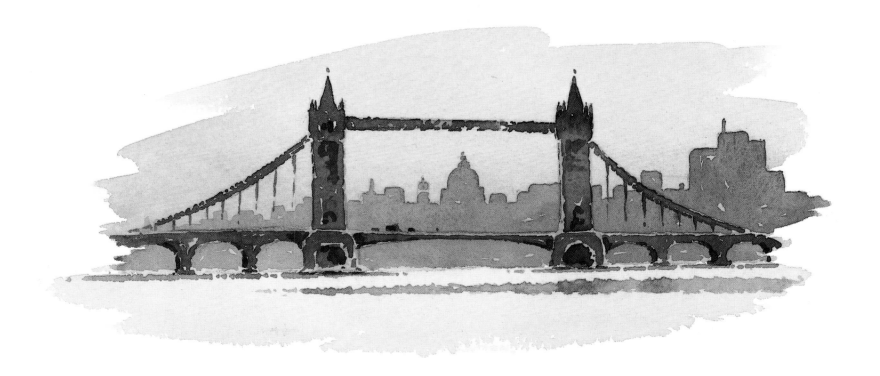

preliminary sketch, descriptive text and some detail from the painting on the left. The black and white sketches were chosen from the three or four I made of each subject and were either redrawn or elaborated a little to aid reproduction. In practice I rarely develop my preliminary sketches to this stage and for simple landscape subjects, comprising just a few fields and trees, my sketches may contain little more than a line to indicate the horizon and perhaps a few lines and marks to show the position of the composition's principal trees.

Preliminary sketches may be made with a variety of drawing implements – pencils of varying blackness, Conté pencils, water-soluble pencils, black crayon, pen and ink, charcoal and so on – and to illustrate the use of some of these I have used a different one for each of the five chapters. It is well worth experimenting to discover which suits you best, though your choice will depend to some extent on your subject. Charcoal is extremely effective for conveying impressions and atmosphere but for subjects containing a lot of detail, something more precise is indicated.

If you study the sketches and paintings in the following chapters in conjunction with the accompanying text, they should help you to produce paintings rich in tone and colour contrast, executed with freshness and panache and, with practice, to tackle landscapes with greater insight, originality and confidence.

(Opposite) *Venice Backwater*

16

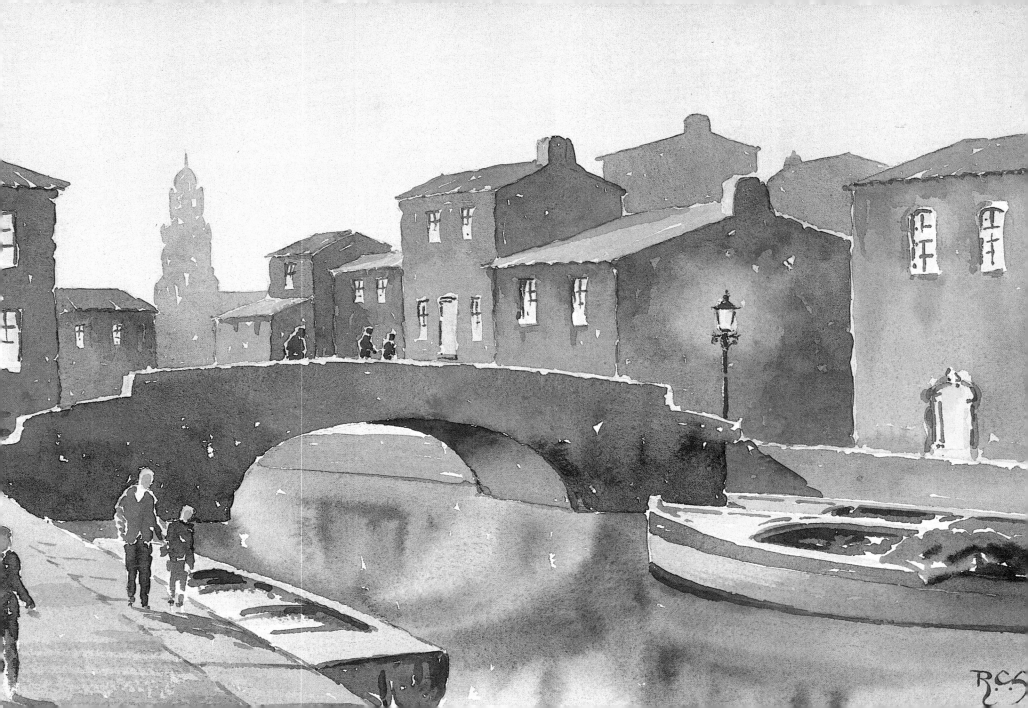

1 COASTS AND HARBOURS

(Opposite) *Sailing
Barges at Anchor*

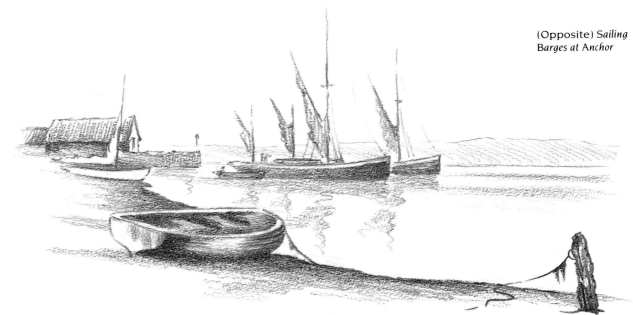

THERE is a wealth of splendid material for painting all around the coastline. Often, complex geology has created a tremendous diversity of land formation and local building material and it is this, coupled with natural vegetation, that gives much coastal scenery its variety and character. The older fishing villages, with their weathered cottages and variety of craft at anchor, are a rich source of subject matter.

Such subjects usually require more preliminary drawing than other landscapes. With waterside buildings often set at odd angles and complex boat shapes demanding particular care, only the very experienced – or foolhardy – would go straight in with the brush. Never sketch directly on to your watercolour paper or the inevitable alterations and erasures will damage its surface and make clear, luminous washes impossible. It is much better to work out your composition on rough sketching paper and then transfer it, by tracing if necessary, to your painting surface.

For the black and white sketches in this chapter, I used 2B and 4B pencils on Not watercolour paper.

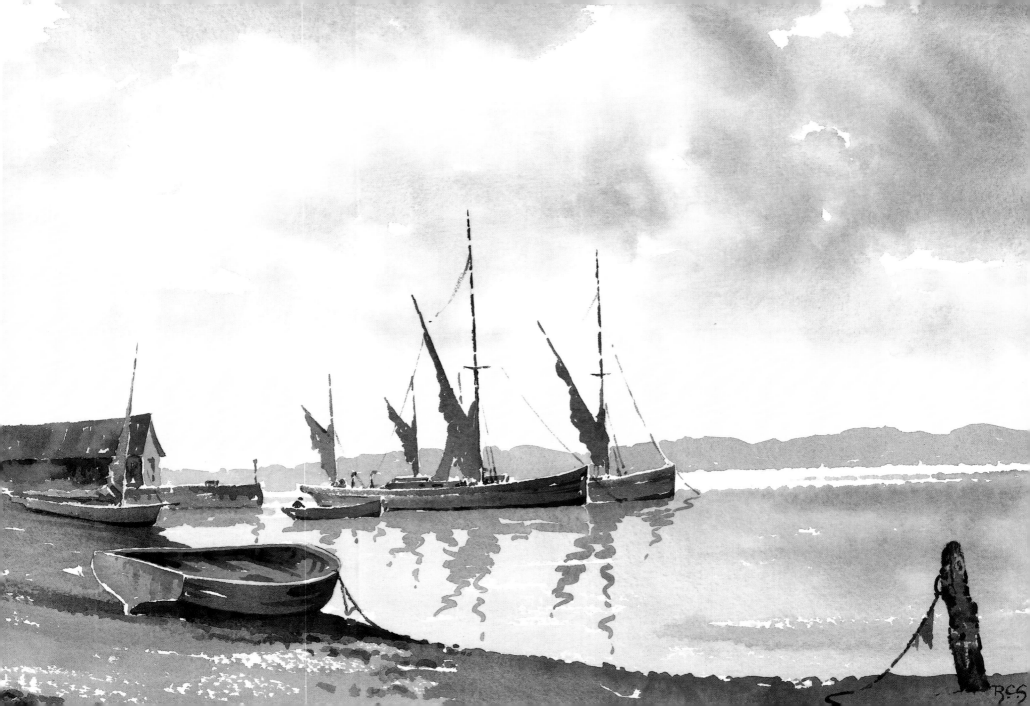

The Quayside

PALETTE

raw sienna
burnt sienna
light red
French ultramarine

PAPER

Arches 300lb
(640gsm) rough

BRUSHES

Two 1in (2.5cm) flats
No.10 and No.8
Sceptre rounds, rigger

ALTHOUGH it only includes a small section of the harbourside, I finally selected the sketch below because I felt it made the most pleasing composition. The buildings are set at varying angles with some overlapping and their sunlit and shadowed elevations, against the backdrop of trees, make an interesting pattern to which the foreground boats also contribute. The main weight of the composition is admittedly well to the right, but the white façade and pale roof of the right hand cottage do much to restore the position. In this instance I could not use heavy cloud shadow on the left to provide compositional balance because I needed strong illumination from that quarter to light up the left facing elevations of the quayside cottages. This strong lateral light produces plenty of tonal contrast and it is this that breathes life into the painting.

This first sketch is pleasant enough, with good tonal contrast, but the buildings are rather strung out in a straight line.

Here the grouping is rather better, but nearly all the compositional weight is on one side.

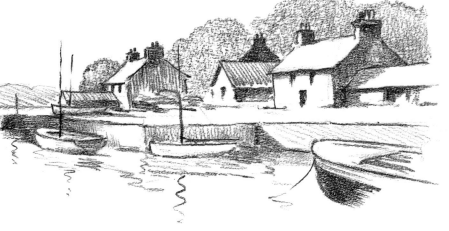

The final sketch

The evening sky had a warm glow to it so I used a graded wash of French ultramarine and light red at the top, shading into raw sienna and light red at the horizon. While this was still wet I applied a deeper version of the first wash with horizontal strokes of a large brush for the warm grey of the stratus clouds. This produced a soft-edged effect which emphasized the peaceful atmosphere of the scene and provided contrast with the treatment of the objects below.

Simplify your subject by omitting unnecessary detail, but first make sure it is unnecessary. Here the quayside clutter is part of the scene so I have included it.

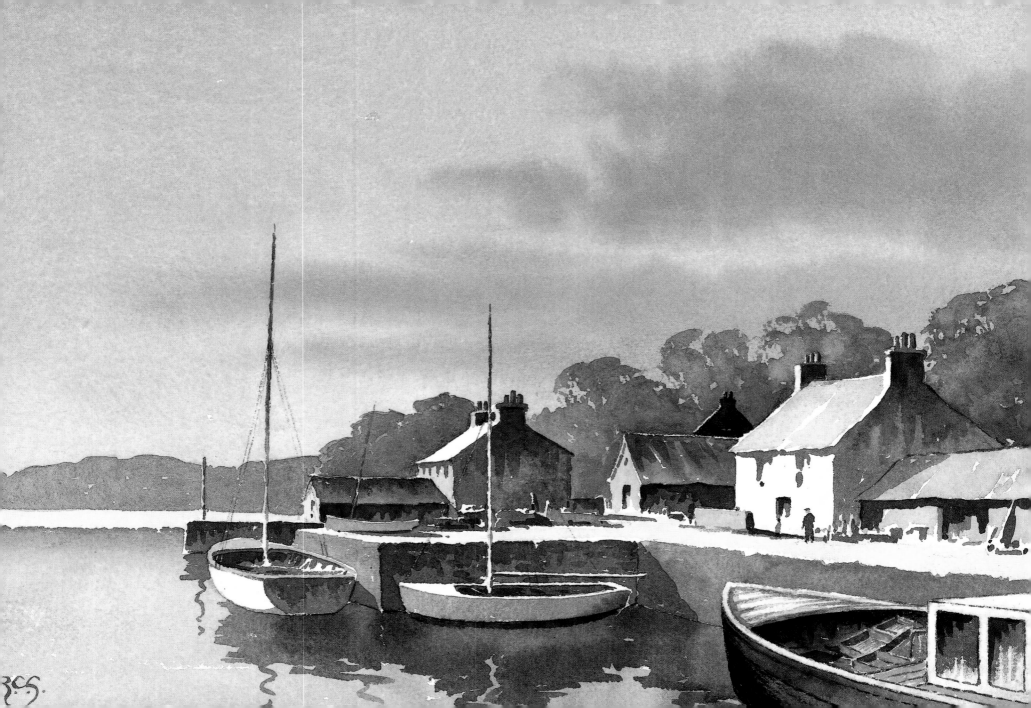

By the Sea

PALETTE

raw sienna
burnt sienna
light red
French ultramarine
Payne's grey

PAPER

Arches 300lb
(640gsm) rough

BRUSHES

Two 1in (2·5cm) flats,
No.14 sable,
No.10 and No.8
Sceptre rounds

THIS is an example of a subject in which most of the tonal weight is firmly on one side. Although the classic solution would be to paint the heaviest clouds on the opposite side, in this instance I wished to feature the very pale tones of the sea and contrast them with the much darker land forms and this meant a correspondingly pale sky – an example of the demands of atmosphere and impact overriding the laws of compositional balance. I see no point in ignoring the rules of good composition for no particular reason, as some 'modern' painters do, but they are not the only, or even the most important considerations, and sometimes have to take second place.

I planned to paint the farm buildings and scrubby foliage boldly and decided to handle the sea and sky areas in a smoother and more restful fashion. It is always worth planning your painting so that there are quiet areas on which the eye can rest, particularly if there are other passages full of movement and incident.

I used a pale wash of raw sienna for the lighter parts of the sky while a liquid wash of light red and French ultramarine served for the clouds. When used in a very liquid form, some slight colour separation sometimes occurs with this mixture and a little of the light red has escaped into the lighter passages on the right of the painting, an effect which might be regarded as a happy accident.

The farm buildings and trees were painted last in strong, warm colours, with plenty of tonal contrast, the effect of which is highlighted by the detail, right.

The strong contrasts of the foreground and the gentler treatment of the background create a convincing feeling of recession.

If there is plenty of incident and activity, plan your painting so that there is at least one quieter area on which the eye can rest.

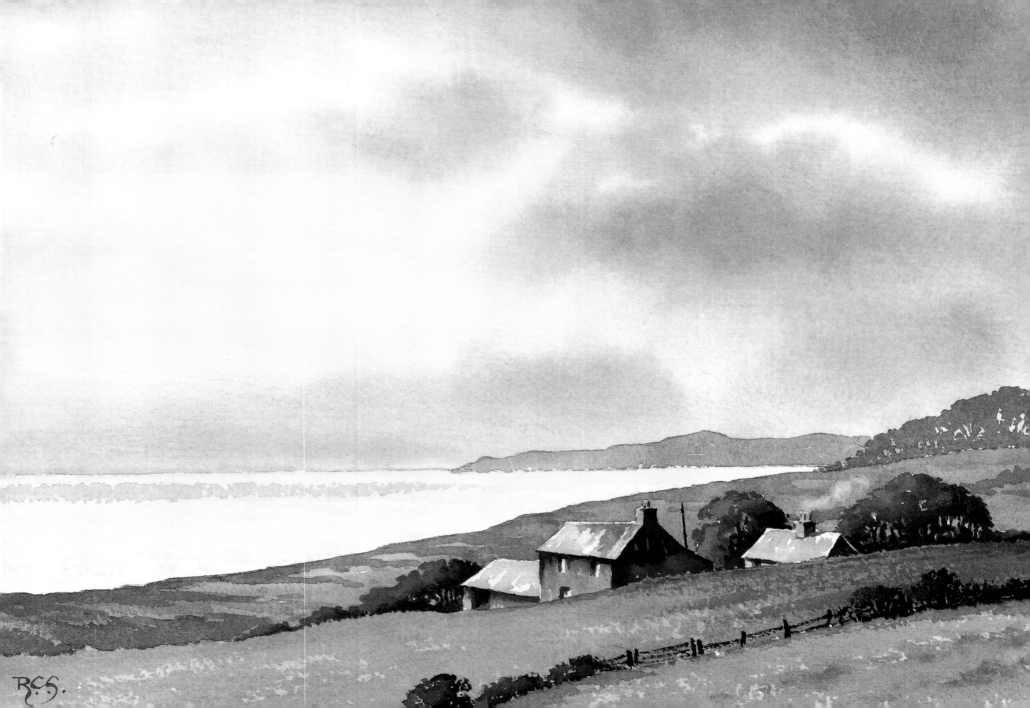

Fishermen's Cottages

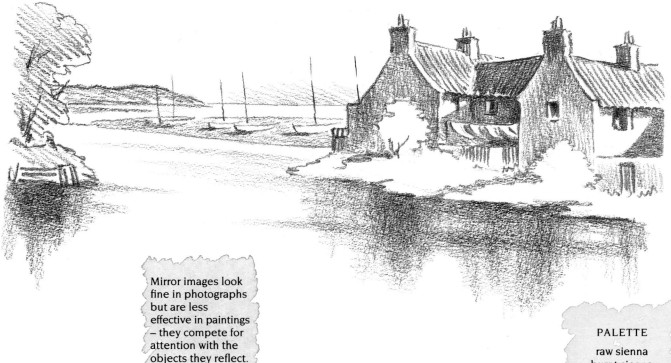

I WAS attracted by the rich colours of the brick and Norfolk pantiles in the fishermen's cottages, now mainly holiday homes, and the glimpse of the sailing dinghies and the open sea beyond. The stunted trees on their timber-reinforced bank on the left provided tonal balance and helped to frame the central vista and direct the eye to the beached boats on their spit of land and the distant headland. The diagonal shadows on the brickwork give the cottages a three-dimensional feel. The line of washing

Mirror images look fine in photographs but are less effective in paintings – they compete for attention with the objects they reflect.

Notice the warm reflected light on the shadowed wall and the crisp accent made by the line of washing against this shadow.

blowing in the wind provides a light accent in a shadowed area and the bush against the dark left hand gable performs a similar function.

Notice how the brickwork of the chimney stacks is very dark in tone so that it registers strongly against the pale sky, and how warm, reflected light lends interest to the area of shadowed wall behind the line of washing. The slope of the pantiles is economically indicated by a few random chinks of white which give a fresher and more spontaneous effect than would a more carefully painted alternative.

The calm water in the foreground was slightly wind-ruffled and this enabled me to paint soft-edged reflections, wet in wet. I felt these complemented the cottages and trees above and were preferable to mirror images which would have competed with them.

PALETTE

raw sienna
burnt sienna
light red
French ultramarine
Winsor blue

PAPER

Arches 300lb
(640gsm) rough

BRUSHES

Two 1in (2.5cm) flats,
No.14 sable,
No.10 and No.8
Sceptre rounds, rigger

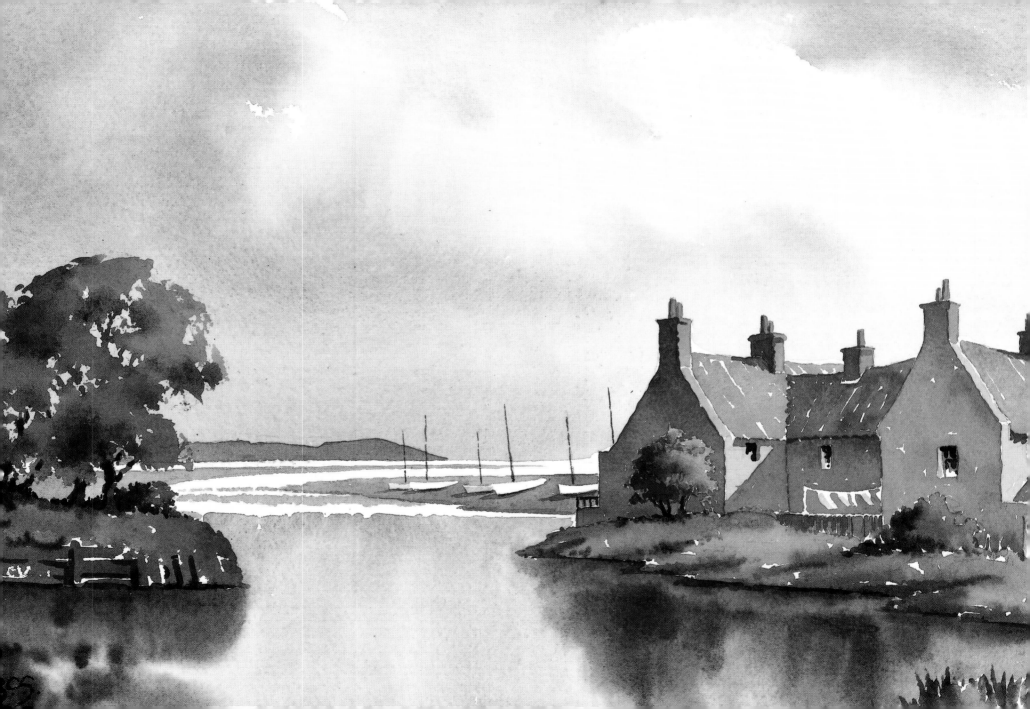

The Fishing Village

THE haphazard arrangement of these quayside buildings made a pleasing composition when viewed at an oblique angle. The strong lateral light produced some crisp tonal contrasts and I was determined to make the most of such features as the white sailing boat against the shadowed sea-wall and the sunlit gable against the darker buildings behind.

I confined my quick pencil study to the group of buildings, though I realised I would have to place something fairly solid on the left of my painting to provide compositional

balance. A boat was the obvious answer and I made a quick sketch of a nearby sailing dinghy.

The sky and the water were mostly cool blue-greys and the warm tans and reds of the buildings provided useful colour contrast. As with all painting, forethought and planning were necessary if I was to do justice to the subject and take the fullest advantage of the splendid tonal and colour contrasts. I rather exaggerated the cool colours of the sky and the water and the warm colours of the buildings and also emphasized the tonal

PALETTE

raw sienna
burnt sienna
light red
French ultramarine
Payne's grey

PAPER

Arches 300lb
(640gsm) rough

BRUSHES

Two 1in (2.5cm) flats,
No.10 and No.8
Sceptre rounds,
rigger

The two small figures stand out against the diagonal shadow behind.

> Placing complementary colours (or colours on opposite sides of the colour wheel) in close proximity can produce vibrant harmonies and bring a painting to life.

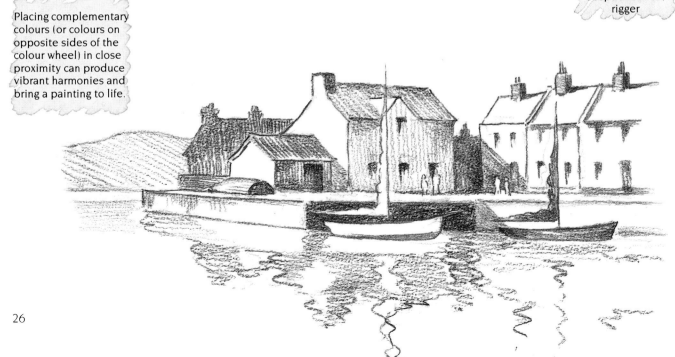

contrasts. Even the tiny figures were placed against shadowed backgrounds to make them stand out. This pause for thought before putting brush to paper, to consider such matters as tone and colour contrasts as well as composition, is always time well spent and can make all the difference between a run-of-the-mill painting and one that has life and sparkle.

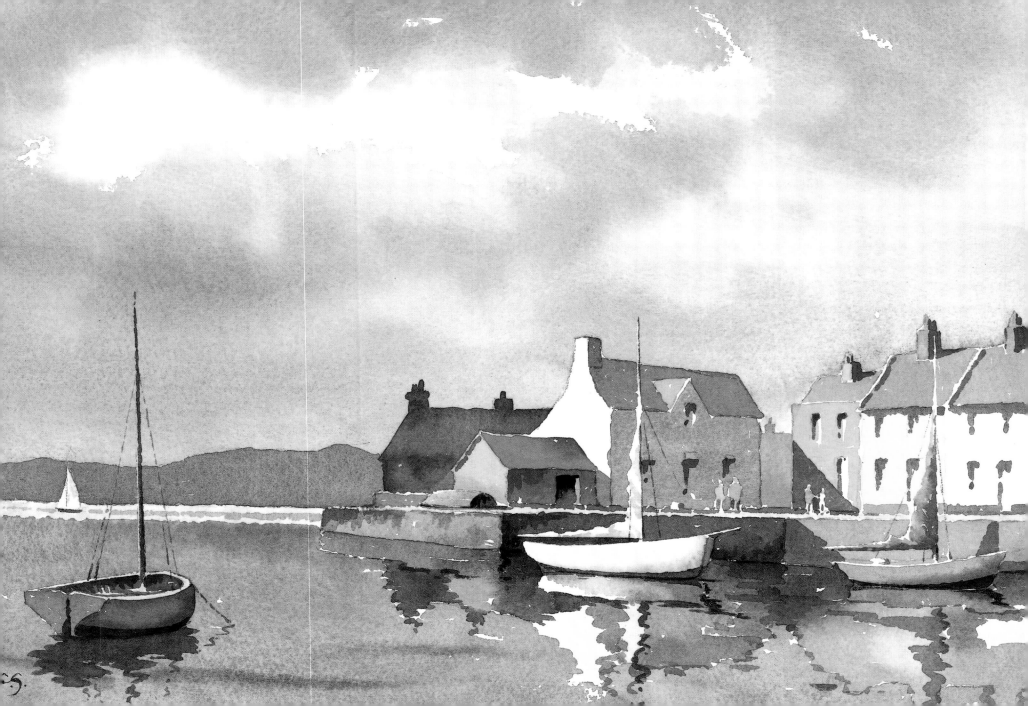

Calm Anchorage

PALETTE

raw sienna
light red
French ultramarine

PAPER

Saunders Waterford
300lb (640gsm) rough

BRUSHES

1in (2.5cm) flat,
No.14 sable,
No.10 and No.8
Sceptre rounds,
rigger

Sunsets are fraught with danger for the unwary watercolourist. While the vivid pinks, purples, oranges and greens of a spectacular sunset look splendid in nature, any attempt to capture them literally is likely to result in a garish and tawdry painting. It is usually better to stick to sunsets with one predominant colour and resist those that contain every colour of the rainbow. Watercolour is a gentle medium and is not at its best when pushed to extremes. Here the overall warmth of the evening light was reflected in every part of the painting and this helped it to 'hang together'.

As the main weight of the composition was on the left I decided to balance it with heavier clouds on the right. In the event I forgot my good intentions and painted the clouds as they were, leaving the moored boats to do their best to perform the balancing act.

Two colours predominate in this painting – light red and raw sienna – which together produce the warm evening glow. The only other colour was French ultramarine which I used in various combinations with light red for the warm purple-greys of the clouds, and the banks of trees and their reflections. The proportion of light red was increased for the tiled roofs and that of French ultramarine for some of the cottage walls and the slated roof on the left.

The warm evening light not only illuminates the west-facing walls and roofs but also catches the edges of features in shadow.

Have a go at sunsets by all means, but do not be carried away by those with a diversity of brilliant colours. Instead choose those with one dominant colour.

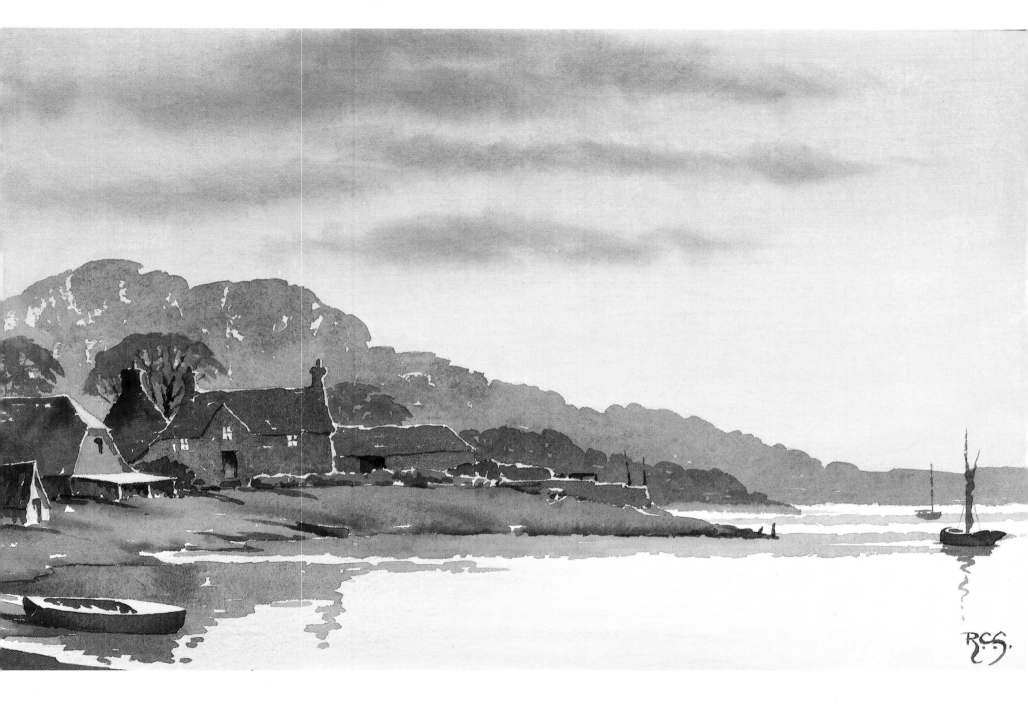

The Yacht Club

PALETTE

raw sienna
burnt sienna
light red
french ultramarine
winsor blue
Payne's grey
cadmium yellow
cadmium orange

PAPER

Arches 300lb
(640gsm) rough

BRUSHES

Two 1in (2.5cm) flats,
No.10 and No.8
Sceptre rounds,
rigger

THE gaily coloured hulls on the yacht club hard were bright accents against the more sombre colours of their setting and made an appealing subject. The strong verticals of the masts and their reflections helped to tie together the mainly horizontal strips of sky, water and land. The deep tones of the landing stage, the rowing boat and the figures on the left help to balance the composition, the main weight of which is on the right, and the heavy cloud shadows serve the same purpose.

The preliminary sketch helped me sort out my tone values and I decided to keep the water pale to provide contrast with the deeper tones of the land forms. Although the day was warm and sultry, there was a hint of thunder in the air and I used a combination of warm and cool greys for the deep tones of the billowing clouds.

The boat sheds, with their rusty corrugated iron roofs, gave me an opportunity to use some deep, rich colour to contrast with the paler tones of the rest of the painting. The reflections in the smooth water were a yellowy green for which I used a liquid wash of raw sienna with a little Payne's grey.

There is plenty of rich colour in rusty corrugated iron!

Do not be afraid to use bright colours for man-made objects – they can add sparkle to the dullest landscape.

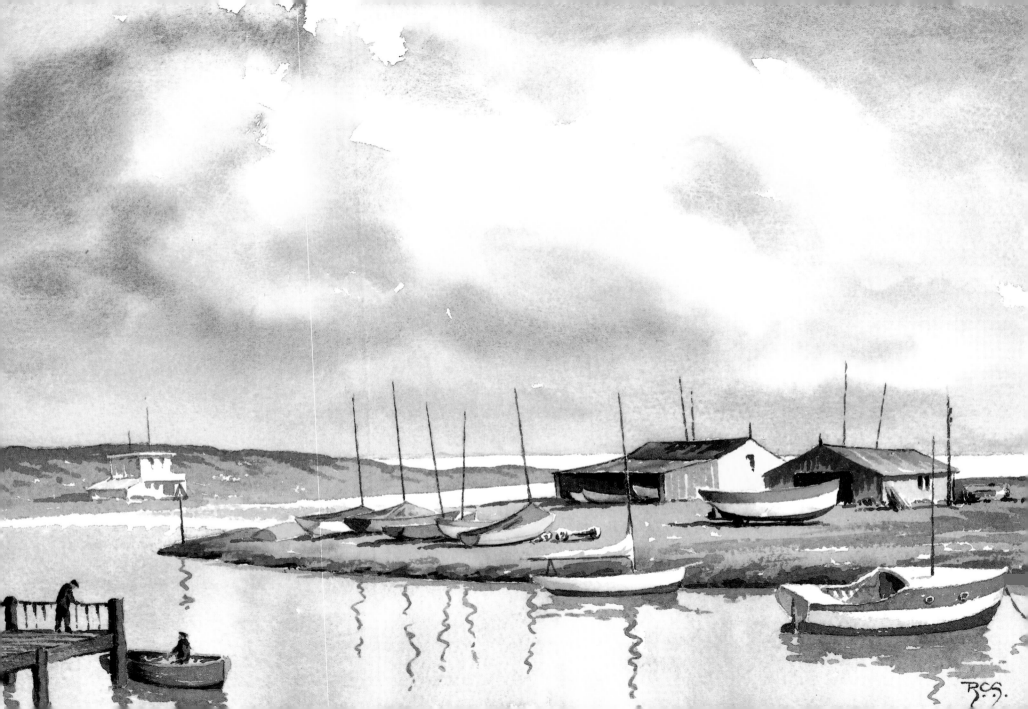

A Cloudy Day

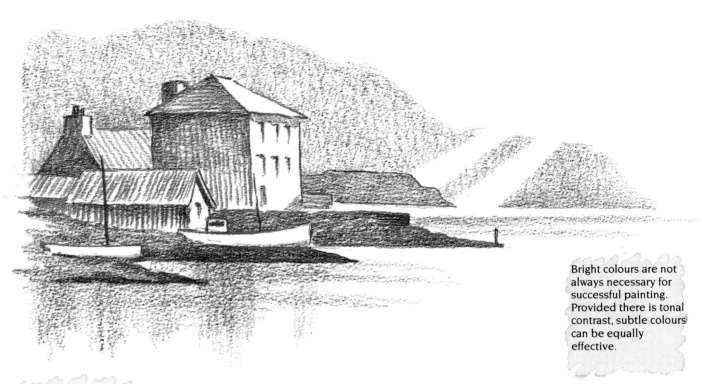

THE watercolourist has less reason than most to complain about the weather, for the vagaries of climate often produce a range of wonderfully atmospheric effects for which watercolour is the ideal medium. Skies of cloudless blue are very pleasant, but misty subtle greys may be just as appealing.

When I visited this familiar Cornish scene there were breaks in the cloud cover with shafts of misty sunlight illuminating parts of the landscape; the colours were muted, with

The broken treatment of the reflections contrasts with the stronger, firmer handling of the objects above.

Bright colours are not always necessary for successful painting. Provided there is tonal contrast, subtle colours can be equally effective.

PALETTE

raw sienna
light red
French ultramarine

PAPER

Saunders Waterford
300lb (640gsm) Not

BRUSHES

Two 1in (2.5cm) flats,
No.10 and No.8
Sceptre rounds

soft greys predominating. I made several quick sketches of the scene from different angles and finally chose this one. I added some land forms in my painting to provide compositional balance on the right.

I began with the sky and flooded the paper with a pale wash of raw sienna tinged with light red. I then applied a second wash of French ultramarine and light red for the warm grey of the clouds and let the two merge together. I added the shoulder of wooded hill with a rather stronger version of the same grey, painting carefully round the buildings, and as the paper was still damp down to the water-line, the edges remained soft. I then removed a little pigment with a moist brush to suggest the shafts of sunlight. I painted the nearer features and their reflections more crisply and this helped to bring them forward.

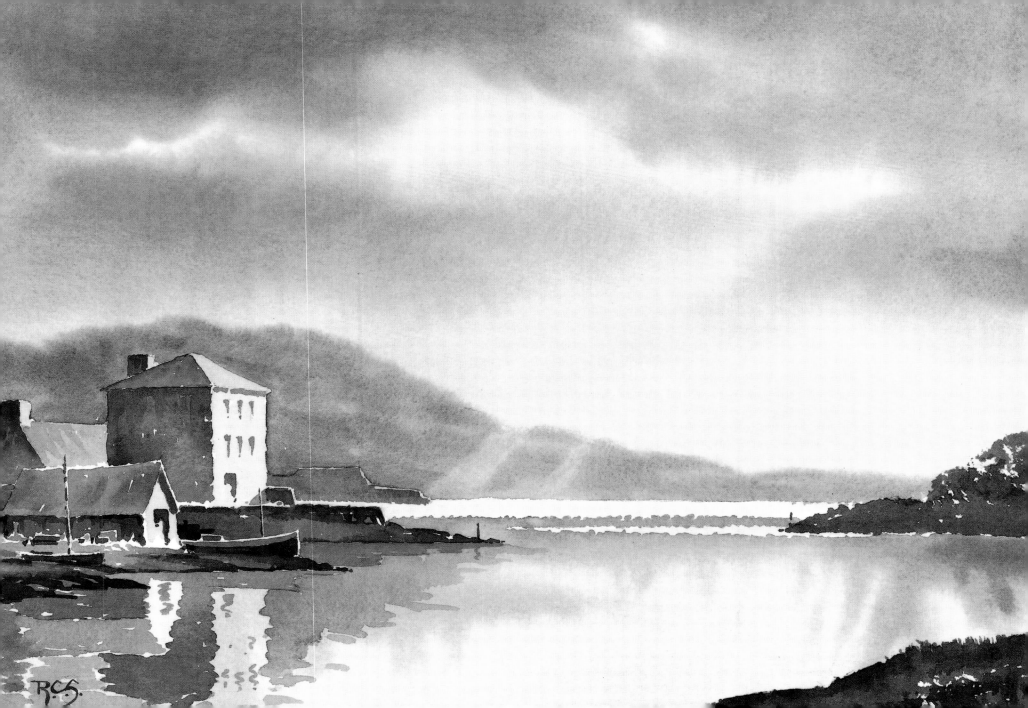

Flood Tide

I MADE this quick watercolour, based on an old sketch, while testing out the new tinted Bockingford paper for the *Leisure Painter* magazine. This colour, a pale grey, served well as a base for the cool impression I wished to create.

I began by preparing two pale washes: one of water with just a touch of raw sienna for the lightest areas of cloud, and the other of dilute French ultramarine and light red for the cloud shadows. I applied these very loosely to indicate the cloud formation and carried them down over the area of foreground water with vertical strokes to suggest the sky reflection. I then let everything dry.

The next step was to indicate the lovely old town of Rye on its little hill and I decided to do this as simply as possible by applying a flat liquid wash of French ultramarine and light red to create a soft grey silhouette, taking care to leave gaps to accommodate the furled sails of the two boats. The French ultramarine granulated a little to produce a slightly textured effect. The middle distance landing stage and trees on the right went in next, followed by the boats and the reflections, and for these I used washes of

Even the rich reds and browns of the sails look dark when seen against a luminous sky.

various combinations of burnt sienna, light red, French ultramarine and Payne's grey. The final touch was the deep-toned foreground, put in very loosely with quick strokes of a large brush which skated over the surface to provide a broken effect suggesting the texture of mud and shingle.

This simple painting only took forty minutes and may suggest to you one method of capturing atmosphere quickly and directly.

If you find the white of watercolour paper rather daunting, well chosen tinted paper can help you over the first hurdle.

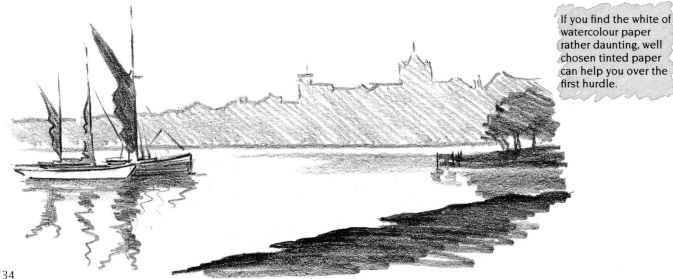

34

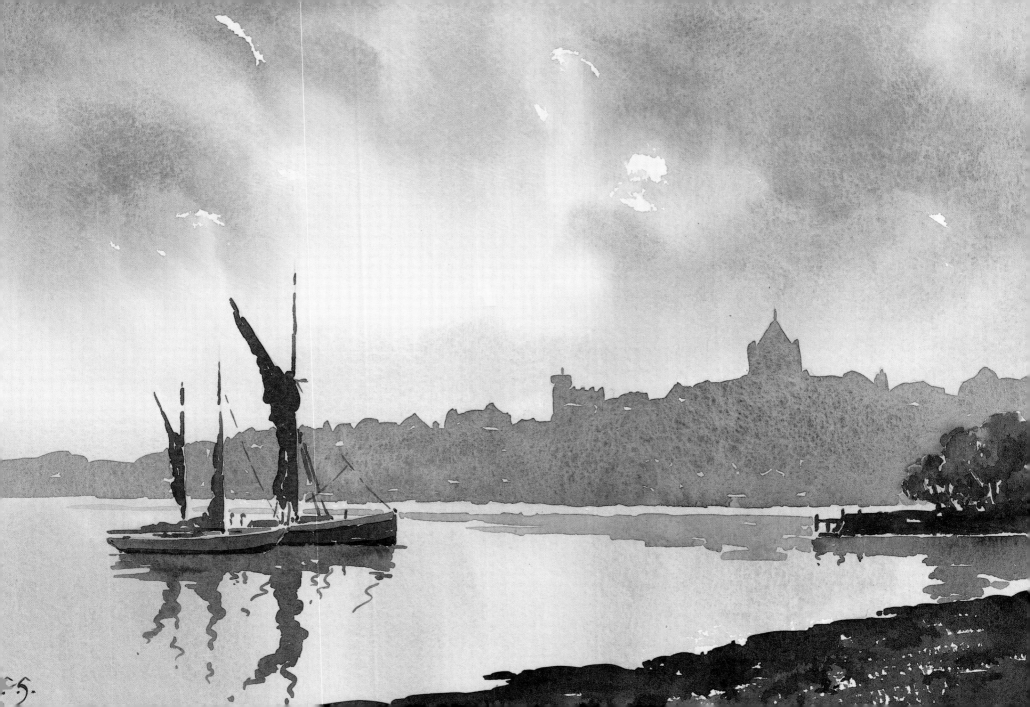

Calm Estuary

PALETTE

raw sienna
burnt sienna
light red
French ultramarine
Winsor blue

PAPER

Saunders Waterford
300lb (640gsm) Not

BRUSHES

Two 1in (2.5cm) flats,
No.14 sable,
No.10 and No.8
Sceptre rounds

THIS view of the Blackwater Estuary at Maldon provides a delightful natural composition, with the strong verticals of the church tower and the sailing barge providing balance. I included a little more of the estuary in my painting, and so used some heavier cloud formations on the right to preserve tonal balance. This is not an accurate representation of the scene for I indulged in much simplification of the attractive jumble of buildings, but it captures something of its atmosphere, which was my objective.

Once again I have used two lines of pale, disturbed water to separate the land from its reflection below and have opted for soft, diffuse reflections to provide contrast with the crisper treatment of the buildings and foliage above. I concentrated on building up the painting with a series of single, clear washes of differing tone and colour. Only on the shadowed sides of the buildings and on the pale stretches of grass were second washes needed, to suggest texture or deeper shadow. It is often tempting to 'tidy up' and add detail, but these temptations should be firmly resisted for the sake of freshness and spontaneity. Clear washes, quickly and boldly applied, produce the best results.

Lines of pale, wind-ruffled water can create a useful break between the landscape and its reflection.

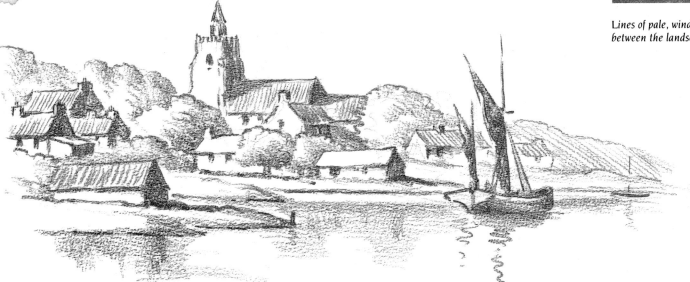

Build up your painting with a series of washes of different tone and colour and reduce over-painting to an absolute minimum for the sake of freshness and clarity.

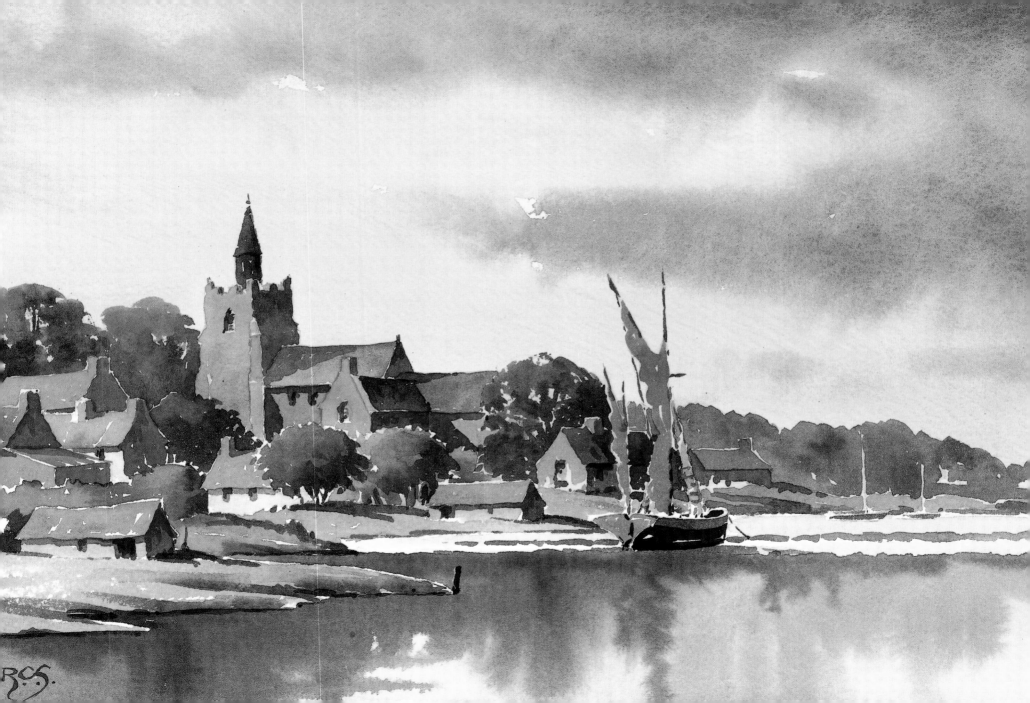

Evening Scene

I FOUND this jumble of boats, fishermen's huts and assorted marine clutter full of interest and appeal. Set against the soft colours of an evening sky and the calm waters of the estuary, it seemed an ideal subject for watercolour. On this occasion I was satisfied with my first sketch and decided to base my painting upon it. I intended to include more of the estuary and achieve compositional balance by placing a moored sailing barge on the right, by including some clouds above

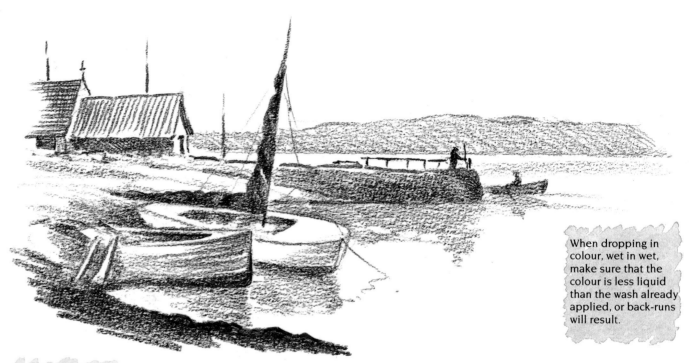

When dropping in colour, wet in wet, make sure that the colour is less liquid than the wash already applied, or back-runs will result.

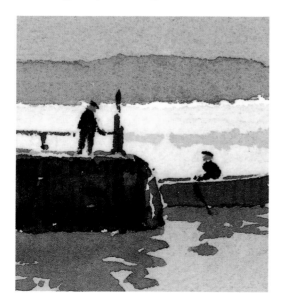

Just a couple of tiny figures can add a touch of human interest to a scene such as this.

PALETTE

raw sienna
burnt sienna
light red
French ultramarine
Winsor blue

PAPER

Arches 300lb
(640gsm) rough

BRUSHES

Two 1in (2.5cm) flats,
No.10 and No.8
Sceptre rounds, rigger

it and by emphasizing the far bank.

I prepared two washes for the sky – the first of raw sienna and a little Winsor blue and the second of raw sienna and light red – and applied them as a graded wash, right down to the water-line. I painted in the clouds with a mixture of French ultramarine and light red, and, as the paper was still wet, obtained the desired soft-edged effect. I repeated the process in reverse for the estuary

below, leaving two pale strips to represent disturbed water. When everything was dry I put in the far bank with another wash of French ultramarine and light red, decreasing its tone towards the left, to suggest increasing distance.

I painted the foreground objects strongly, to make them come forward, but took care to ensure the warm glow of the sky found an echo in the lighter passages.

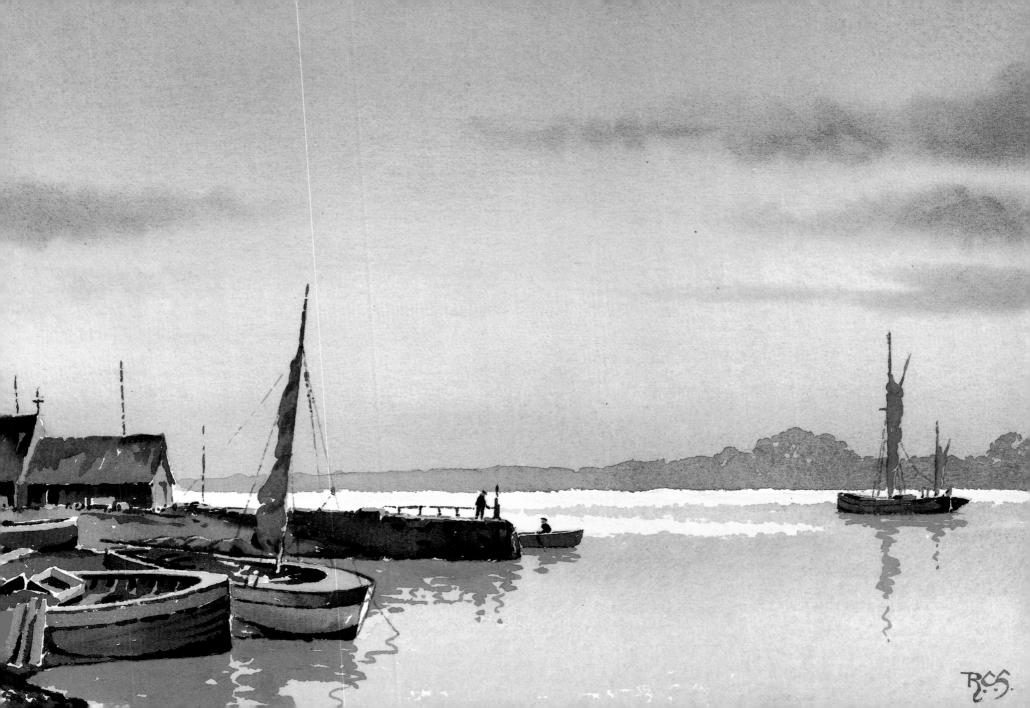

2 COUNTRY SCENES

(Opposite) *The River Test*

W ATERCOLOUR is the ideal medium for capturing the atmosphere and subtle colouring of country landscapes. The convenience and portability of well chosen field equipment enable us to explore the countryside to our heart's content without fatigue and to find all manner of interesting and inspiring subjects. I am constantly delighted at the seemingly endless supply of attractive material to be found around my home in the county of Kent, in England, if one leaves the main roads and explores the byways and lanes of The Weald. Kentish farms have a character of their own and their oast-houses for drying hops, their barns and farmhouses, often seen against a backdrop of sheltering trees, are a delight.

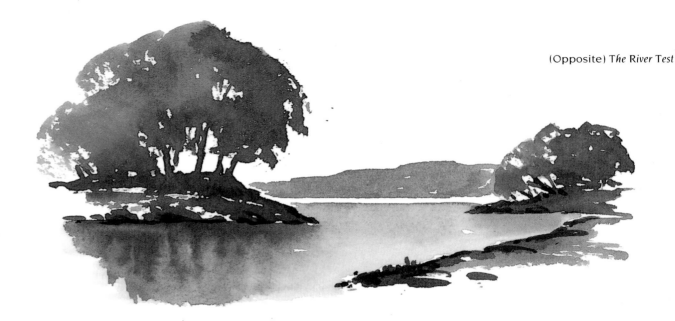

Inexperienced artists often find water difficult to paint and tend to avoid it. This is unfortunate for I believe it can greatly enhance the interest and appeal of landscapes and I have included a number of paintings which feature water in this chapter in the hope that they will encourage you to tackle rivers, streams, lakes, ponds and even puddles for yourself.

I made the preliminary sketches in this chapter with black Conté pencil, a useful and versatile drawing implement with which it is equally possible to produce fine lines and broad areas of tone.

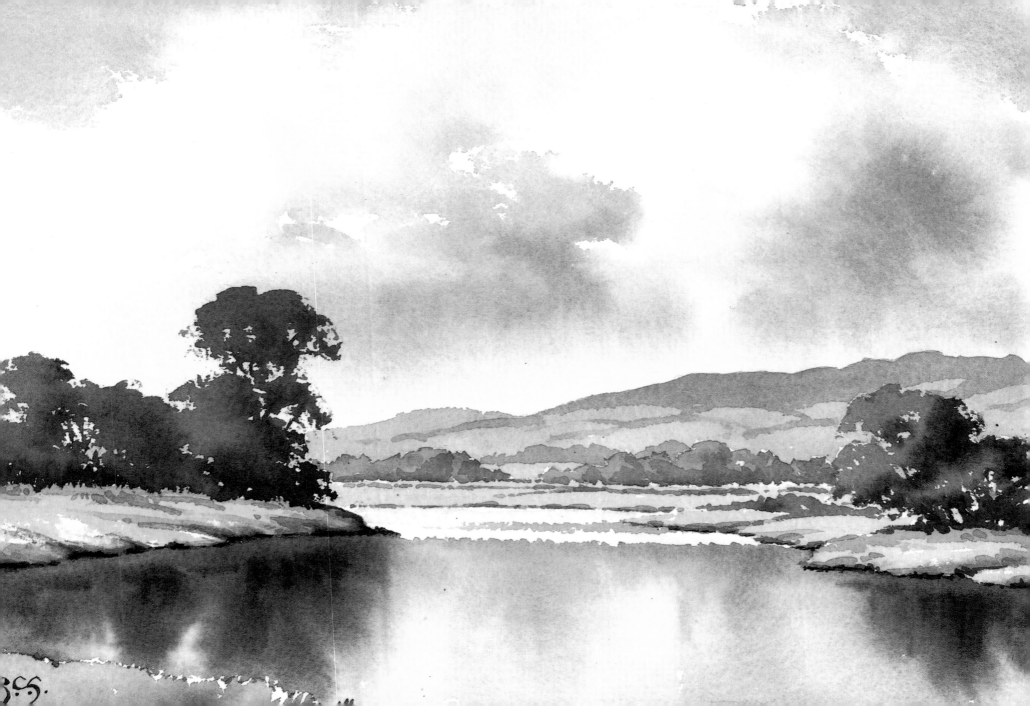

The Farm

THIS is the sort of farming scene to be found throughout The Weald of Kent. I adopted this particular angle for several reasons; the buildings are seen at an angle, with both sunlit and shadowed elevations, which helps to give them a solid and three-dimensional appearance and their overlapping helps to show their relationship to one another. The hop poles and heavy foliage on the left help to balance the main weight of the composition which is on the right; and the puddled track leads the eye into the centre of the painting while the farm gate carries it on to the glimpse of blue-grey distance beyond.

I was attracted by the warm colours of the old clay tiles on the oast-houses, the small

In this sketch the group of farm buildings is rather too central and as most of it is in shadow, there is little opportunity for tonal contrast.

Here the compositional balance is sound, but none of the building elevations is in shadow and the lack of tonal contrast imparts a flatness to the group.

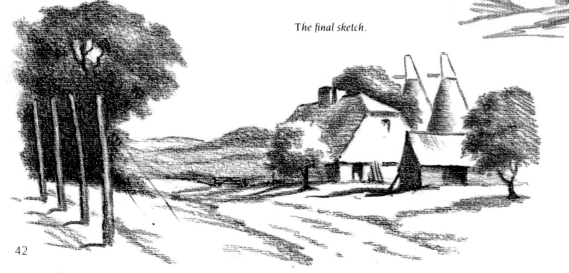

The final sketch.

barn and the 'cats-slide' roof of the farmhouse. These were various combinations of raw sienna, burnt sienna and light red, with a little added green for the moss and weather staining. The tiles in shadow were deeper tones of light red, French ultramarine and burnt sienna. I varied the colours of the trees from a warm autumnal hue (raw sienna, burnt sienna and Payne's grey) to a much cooler green (Payne's grey and raw sienna), which also served for the shadows on the grass. I used masking fluid for the white cowls of the oast-houses and for the upper halves of the hop poles.

Always look for variety in the colour of your trees and never paint them all exactly the same.

42

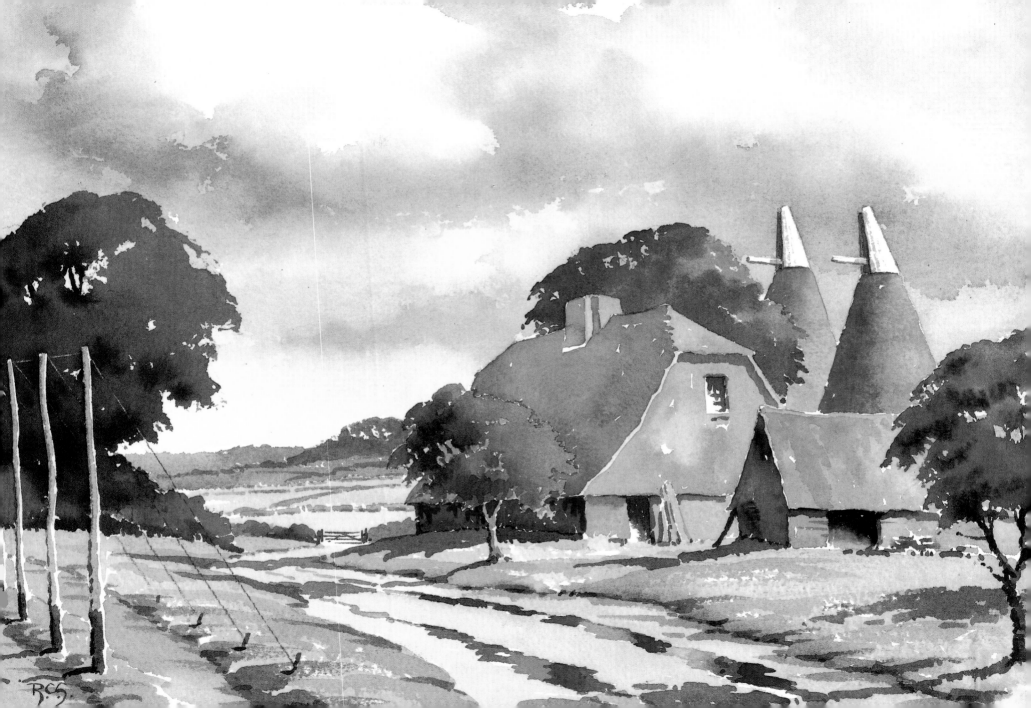

The Young River

THIS delightful little river rises on Dartmoor whence it carries boulders downstream, when in spate, to line its banks and create a natural rock garden, with ferns in great variety growing from every crevice. The damp conditions encourage the growth of moss and lichen and there is an overall greenness about the scene which compels the artist to look for other hues if colour harmony is to be achieved. From this viewpoint a solid bank of distant trees was visible, and its colour, a soft, blue grey, was helpful in this respect, while the warm tones

PALETTE

raw sienna
burnt sienna
light red
French ultramarine
Winsor blue

PAPER

Arches 300lb
(640gsm) Not

BRUSHES

1in (2.5cm) flat,
½in (1.3cm) flat,
No.14 sable,
No.10 and
No.8 rounds

A pale yellow-green wash against a darker background can suggest sunlit foliage.

of some of the river bank plants made another useful contribution.

One of the problems in tackling a subject such as this arises from the mass of detail in the foliage. Distant trees can be seen as masses and treated accordingly, but, close at hand, there must be some indication of individual leaves. The artist should not be tempted, however, to paint every leaf and every twig, or over-complication and

overworking will result, with freshness and clarity the first casualties.

Here I have used broad washes of a pale yellowy green (raw sienna with a touch of Winsor blue). The broken outlines and superimposed slightly darker second wash help to suggest backlit foliage. The dark tones of the tree trunks and the branches help to create an interesting interlocking pattern.

Foreground foliage requires some concession to leaf forms, but avoid over-complication.

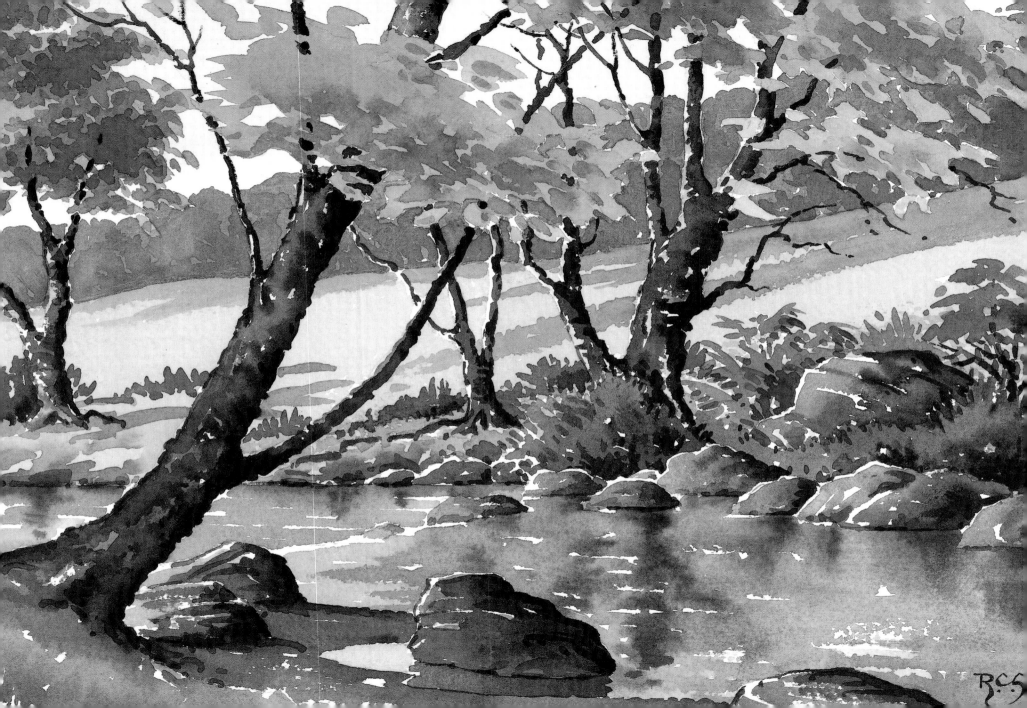

The River Scene

PALETTE

raw sienna
burnt sienna
light red
French ultramarine
Winsor blue
Payne's grey

PAPER

Arches 300lb
(640gsm) rough

BRUSHES

1in (2.5cm) flat,
½in (1.3cm) flat,
No. 14 sable,
No.10 and No.5
Sceptre rounds

Rivers are fascinating subjects to paint and can vary enormously in appearance, depending on the conditions of light and wind. On still days the reflections can be deep-toned and appear much darker than the banks. At other times, if the breeze is catching the surface of the water, bands of light can be seen. In windier conditions the whole river can be pale-toned as the steep-sided ripples of the disturbed surface reflect the sky above rather than the scene beyond.

I chose this view of the Sussex Ouse for a variety of reasons. I like the way the river curves into the centre of the landscape while the chalk scar in the distant hills finds an echo in the pale tones of the river – for both,

the white of the paper. The starkly outlined hills provide a calm but dramatic background and their cool, grey greens contrast effectively with the russets of the autumnal trees and the warmer green of the foreground grass.

I decided to make the most of the contrasts in light and shade and exaggerated the depth of tone of the river banks in order to make the water shine. The dark figures of the anglers help to emphasize this contrast and also provide a focal point.

The hills were a pale wash of Payne's grey and a little raw sienna and to this I added shadow, wet in wet, with French ultramarine and a touch of light red. There were a few patches of scrub but I omitted them in order to preserve the smooth sweep of hills.

Another example of human activity adding interest to a painting.

Do not be afraid to omit detail if it interferes with the effect you wish to create

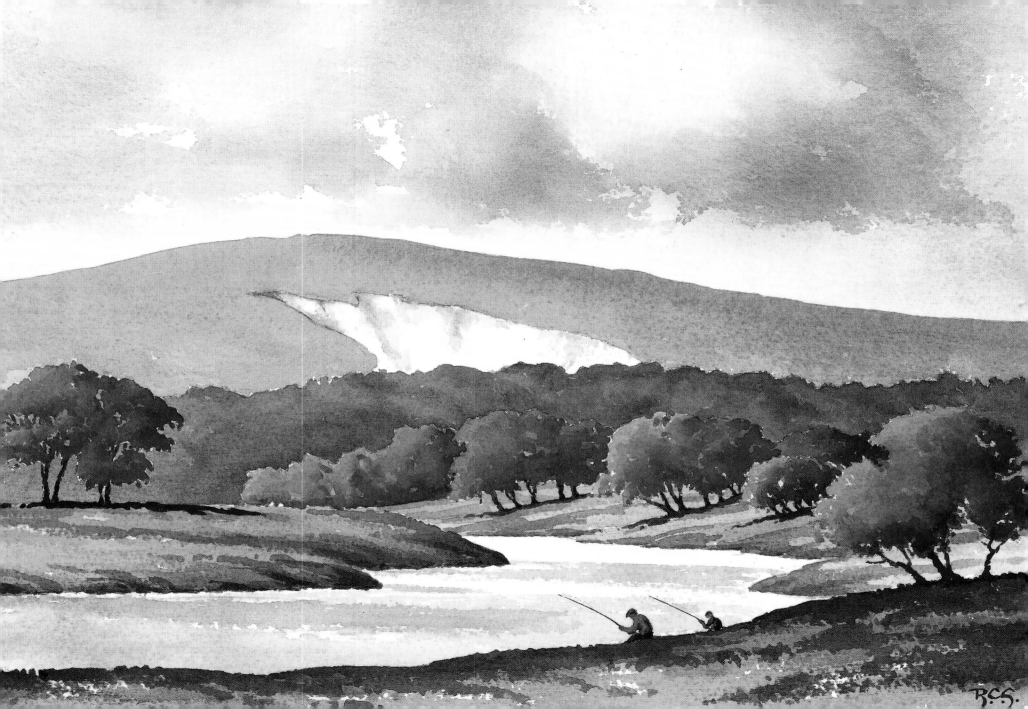

The Farm Pond

THIS is an example of a subject which forms a good natural composition and it is worth considering just what contributes to its harmony and balance.

To start with, the group of farm buildings is nicely balanced by the large tree on the left. The buildings themselves are seen at an angle, with plenty of overlapping, and so relate to one another. The direction of the sun affords ample scope for placing lights against darks and these tonal contrasts help to give the buildings a three-dimensional appearance. The oast-house is well off-centre

PALETTE

raw sienna
burnt sienna
light red
French ultramarine
Winsor blue
Payne's grey

PAPER

Arches 300lb
(640gsm) rough

BRUSHES

Two 1in (2.5cm) flats,
No.14 sable,
No.10 and No.8
Sceptre rounds

You can create a quick impression of the broken outline of foliage by using the side of your brush on rough paper.

to the right and, with the trees, breaks the line of the horizon.

The curving track is of modest size and leads the eye into the heart of the painting. The lines of hedge perform a similar function while the pond provides useful foreground interest.

The trees stood out boldly against the sky and I emphasized this tonal contrast by keeping the lower sky very pale. There were equally strong contrasts between the sunlit and shadowed elevations of the buildings and to these, too, I did full justice. The

foreground grass was a pale wash of raw sienna with just a touch of Winsor blue and I later added some texture, using a dragged-brush technique and a rather stronger mixture of the same colours.

Because the scene was a fairly busy one, I decided that soft reflections in the foreground water would provide welcome contrast. I applied a wash of pale raw sienna to the whole of the pond area and painted in the reflections, wet in wet, using vertical brush strokes and roughly the same colours as the objects above.

When there is conflict between good composition and accuracy with no satisfactory compromise, I usually sacrifice accuracy – unless, for example, the painting is a commission to paint a particular place.

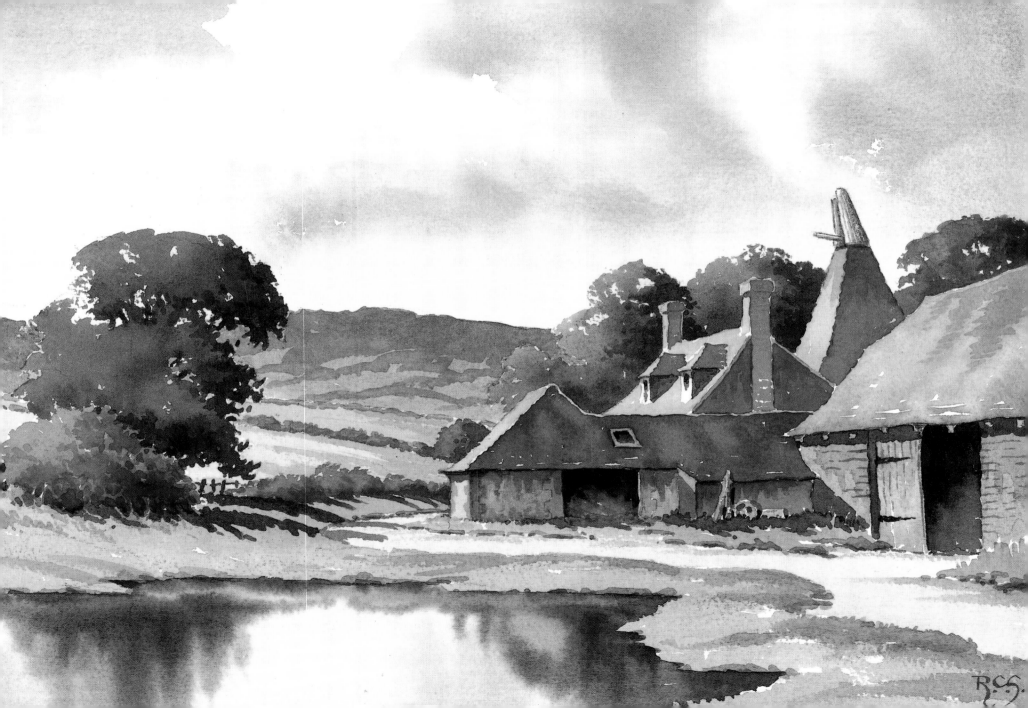

A Wet Winter

THIS painting was an attempt to capture something of the atmosphere of a raw February day, with large puddles in the road and more rain to come from an overcast sky. I usually try to avoid such a large expanse of foreground road, but as it is effectively broken by the standing water, no harm is done. The composition works well, with the lane curving into the centre of the painting – always a useful ploy – and the large bare tree on the left balancing the white-washed cottage on the right. Most of the construction lines lead the eye to the white gate, which

PALETTE

raw sienna
burnt sienna
light red
French ultramarine
Payne's grey

PAPER

Arches 300lb
(640gsm) rough

BRUSHES

Two 1in (2.5cm) and
½in (1.3cm) flats,
No.14 sable, No.12
and No.10 Sceptre
rounds

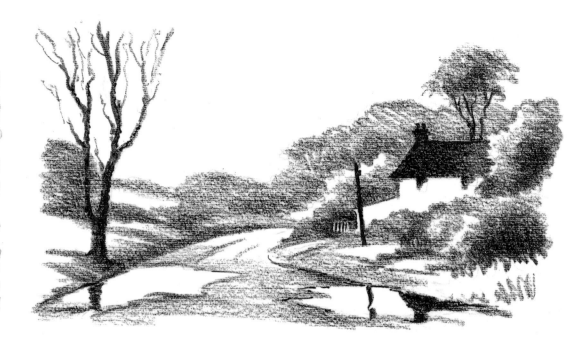

Reflections in puddles can add interest to a flat expanse of foreground road.

becomes an unobtrusive focal point. It is not good practice to let the margins of the road, or any other significant lines for that matter, emanate from the very corners of the painting and you will see that this has been avoided.

The colours, although rich, are comparatively subdued as befits the subject, but there is plenty of tonal contrast, notably where the white cottage and the pale puddles abut the deeper tones of their surroundings. There are several washes of French ultramarine and light red: a pale one

for the roadway, a middling one for the distant trees and a very dark one for the cottage chimney and roof. This useful combination also served for the shadows in the nearer trees, bushes and hedgerows, and I used a cooler version for the cold grey of the clouds.

As I was walking down this lane late one evening, I observed the colours were all cool blues and greys, but a warm, welcoming light shone from the cottage windows – perhaps a theme for another painting.

Landscapes do not always have to be painted in spring, summer or autumn. Rowland Hilder was an artist who managed to capture the magic of winter.

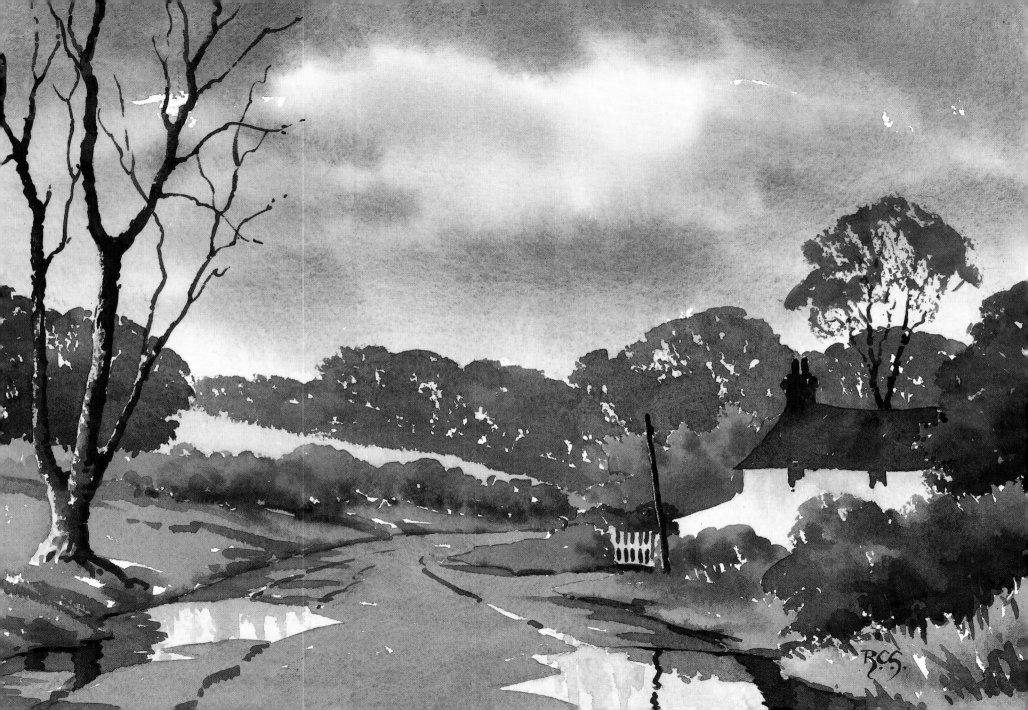

On the River

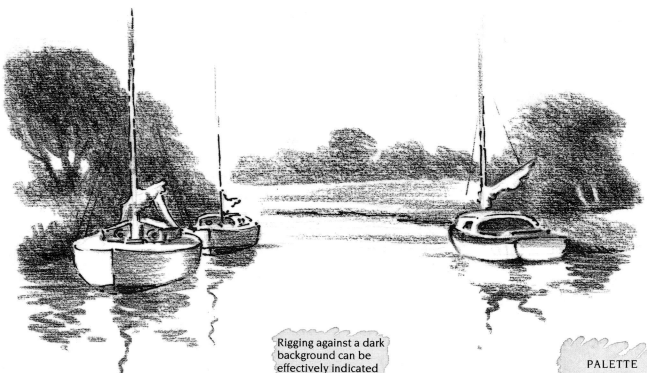

IVERS always make attractive subjects, particularly if they are handled simply with fresh, transparent washes. This scene on the Medway looks as though it has been painted from a boat moored in the centre of the river, but the right hand bank curved round sharply to the left and I was in fact on terra firma. Of my several sketches, I liked this one best. It has good tonal balance and although the river bears to the left, it is not allowed to carry the eye off the paper. The two strips of pale, disturbed water separate the reflections from the far bank, while the

The granulation of French ultramarine can suggest texture in distant foliage.

Rigging against a dark background can be effectively indicated with the sharp corner of a broken razor blade.

vertical masts tie together the horizontal bands of sky, land and water.

I drew the boats with some care and also pencilled in the curving margins of the river, but the rest was all direct brushwork. Trees always look more spontaneous and effective if free brush strokes do the work; the careful filling in of pre-drawn shapes never works as well. The line of distant trees was a single wash of French ultramarine and light red,

with a little raw sienna dropped in here and there. French ultramarine often granulates, particularly on rough paper, and here it helps to convey the texture of the foliage. I slightly exaggerated the depth of tone of the nearer trees so that the moored boats would register more strongly against them. I painted the reflections very simply and did my best to convey the rippling surface of the water.

52

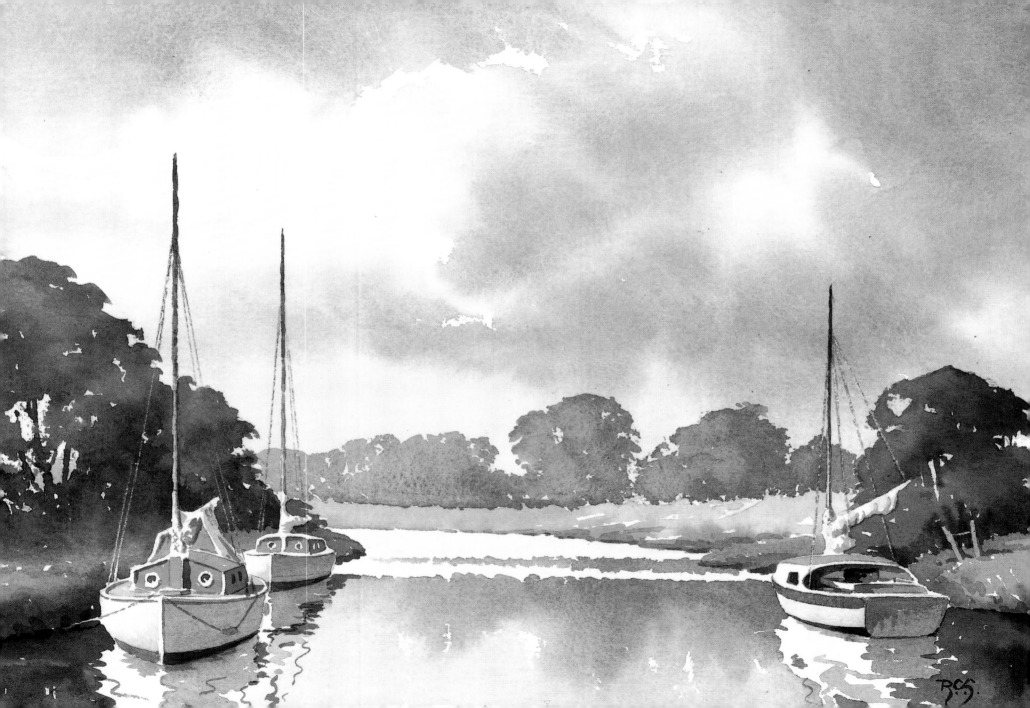

At Anchor

THIS scene, painted in the Norfolk Broads, appealed to me for a variety of reasons. Boats and their reflections in smooth water are usually a gift for the watercolourist and this group made a pleasing tonal contrast with the backdrop of dark trees, while the deep brown of the wooden landing stage and the various Plimsoll lines provided useful additional contrast. These dark lines were of particular importance as there was little tonal or colour contrast between the hulls on the right and the surrounding water.

As the main weight of the composition

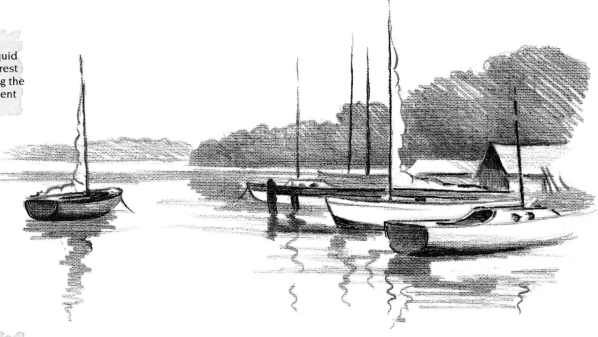

Boldly applied liquid washes are the surest means of capturing the shine and movement of limpid water.

Boldly applied liquid washes can effectively suggest reflections in smooth water.

PALETTE

raw sienna
burnt sienna
light red
French ultramarine
Payne's grey

PAPER

Arches 300lb
(640gsm) rough

BRUSHES

Two 1in (2.5cm) flats,
No.14 sable, No.10
round, rigger

was on the right, I placed most of the cloud shadow on the left and, for good measure, introduced a moored sailing boat with a dark grey hull to provide additional tonal balance. It is all too easy with a subject such as this to become bogged down in detail and a conscious effort has to be made to simplify forms wherever possible and rely on boldly applied, full washes for the desired effect. Provided sufficient thought has been given to placing lights against darks, this approach usually produces an effective impression of the subject.

Rigging often presents something of a problem for if everything is included, the result can look rather like a cat's cradle. The best solution is usually a compromise, with just a few lines being boldly suggested with the aid of a rigger. Apart from the deep green of the bank of trees (Payne's grey with raw and burnt sienna), there is not a great deal of colour in this painting, much of which consists of pale, cool greys. However, the warm burnt sienna and light red of the buildings strike a vibrant note and help to bring the scene to life.

Late Summer

DISTANT church spires often make splendid focal points and this one is no exception. The composition is not a perfect one, with most of the tonal weight on the right, but if I had moved my position to include some trees on the left, the church tower would have been hidden, with only the tip of the spire visible. I would, in fact, have lost more than I gained and, in any case,

perfect composition is not the be-all and end-all of painting. I could have moved the heavier cloud shadows to the left, and that would have improved the tonal balance a little, but the afternoon light was streaming in from that quarter, an impression I wanted to retain.

I painted the sky first and allowed the washes to blend, with only a few hard edges.

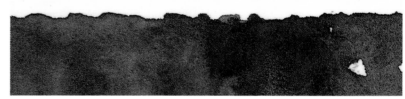

Soft wet in wet reflections contrast effectively with the crisper treatment of the trees above.

> Always aim for good composition but remember other considerations must sometimes take precedence.

It was late summer and autumnal tints were already appearing in the trees. I made the most of these, and, in fact, exaggerated them, to add interest and variety. The line of distant trees on the left was a single wash of pale French ultramarine and light red.

I have introduced strips of pale, disturbed water to separate the trees from their reflections. I applied a pale wash of raw sienna over the area of the smooth water and painted in the reflections, wet in wet, with colours roughly echoing those of the trees above, leaving a ragged edge at lower right to accommodate the foreground reeds.

PALETTE

raw sienna
burnt sienna
light red
French ultramarine
Winsor blue

PAPER

Saunders' Waterford 300lb (640gsm) Not

BRUSHES

Two 1in (2.5cm) flats, No.14 sable, No.12 and No.8 Sceptre rounds

56

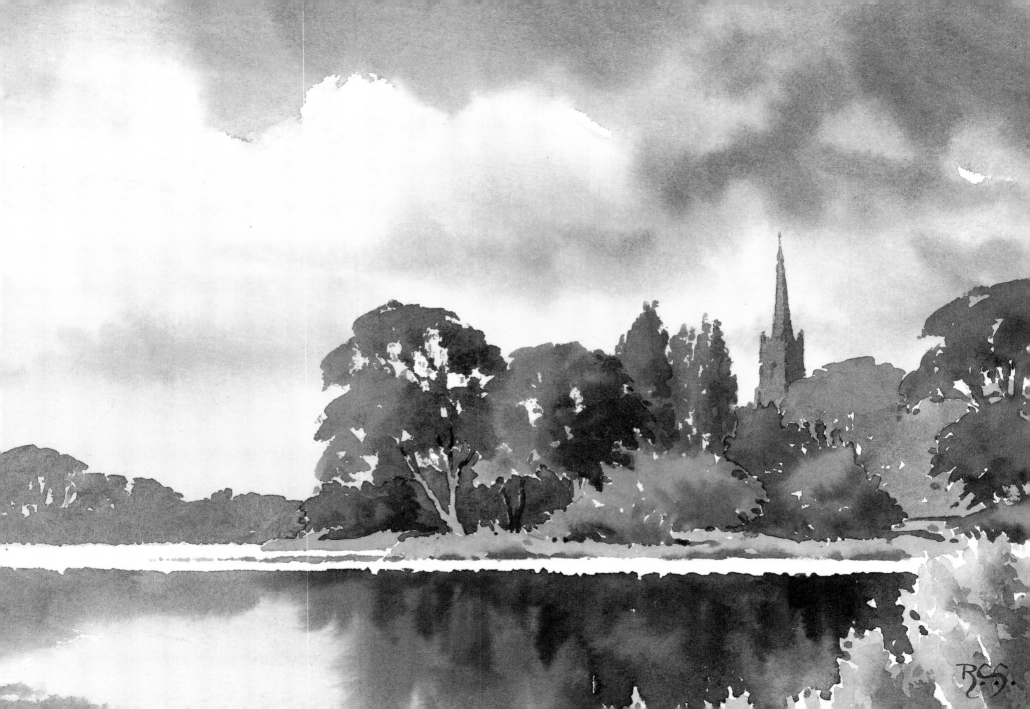

An Inland Waterway

PALETTE

raw sienna
burnt sienna
light red
French ultramarine
Winsor blue
Payne's grey

PAPER

Arches 300lb
(640 gsm) rough

BRUSHES

1in (2.5cm) flat,
½in (1.3cm) flat,
No.14 sable,
No.10 and
No.8 Sceptre rounds

Smooth water with lively reflections is a very rewarding subject for the watercolourist. The secret of success is to apply fresh washes boldly and quickly, and even if the reflections are not quite in the right place, the result is likely to look better and more spontaneous than some painstaking correction.

Inland waterways are a rich source of such subject matter, though an increase in the number of powered craft plays havoc with those reflections, to the indignation of artist and angler alike. I prefer white sails to the coloured variety and the painter, unlike the photographer, can indulge his prejudice. Here, the white of the windmill finds an echo in the sails and hulls of the boats and their reflections. The windmill stood out boldly against the clump of dark trees and I placed the sailing dinghy against the same

When painting rippling water, try to 'freeze' a moment in your mind's eye and apply your prepared washes boldly.

The whites of the sail and the windmill register strongly against the dark background of trees.

background for the sake of further tonal contrast – a contrast which is repeated in the reflections.

I included a foreground bush and some reeds on the left to improve the tonal balance of the composition. I used full, liquid washes in all parts of this painting and applied them quickly and directly, a technique which I believe produced a fresh and lively effect in keeping with the subject.

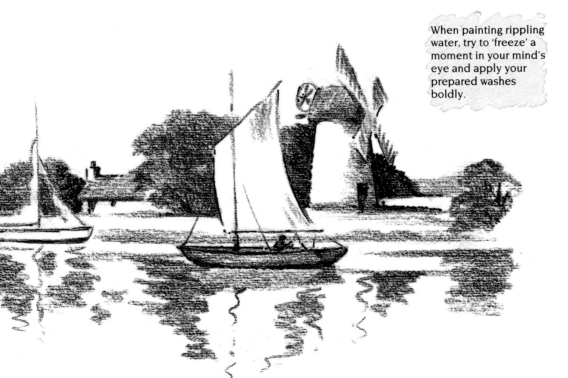

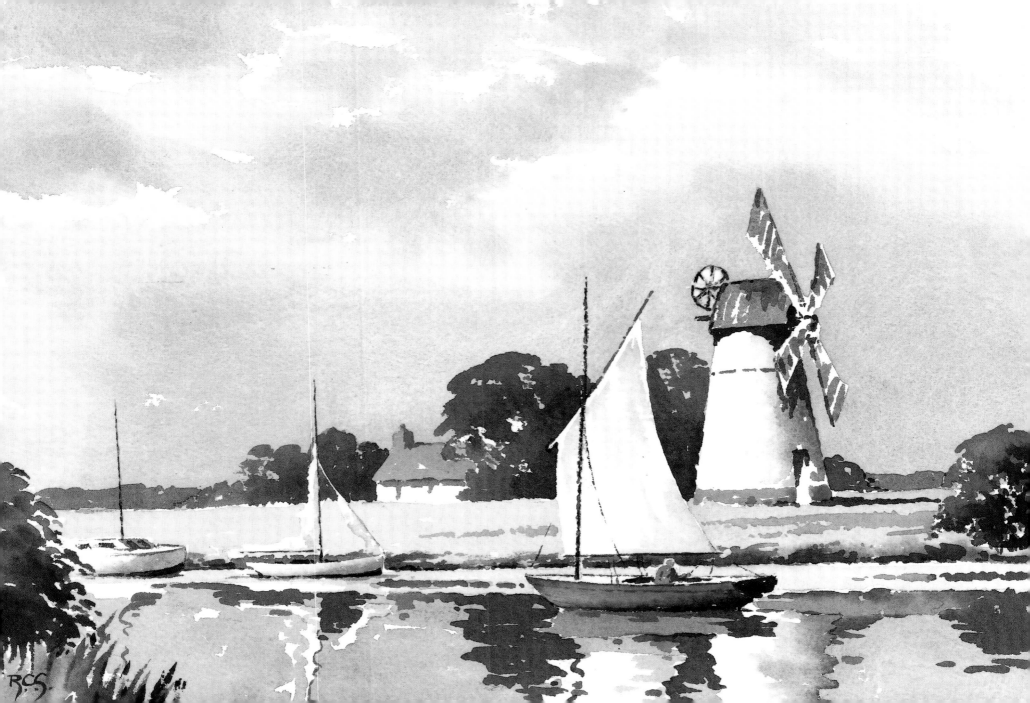

The Bridge

PALETTE

raw sienna
burnt sienna
light red
French ultramarine
Winsor blue
Payne's grey

PAPER

Arches 300lb
(640 gsm) rough

BRUSHES

Two 1in (2.5cm) flats,
No.14 sable, No.12,
No.10 Sceptre rounds

THIS fine old stone bridge spanning the river Medway is popular with painters, and groups from local art clubs are frequently to be seen busily at work on the river banks nearby. There are a number of points from which the bridge may be seen to good advantage and the final choice was not an easy one. I made my first sketch much closer to the bridge with the arches and buttresses at an oblique angle against a background of dark trees. At close range the old stonework has a wonderful patina and its treatment would be a test of the watercolourist's skill with broken-wash and dry-brush techniques.

I finally decided to develop this sketch because I felt it not only made an attractive composition but also called for bold and straightforward watercolour treatment. The bridge was in full sunlight and stood out effectively against the trees and distant hills. It was at a slight angle so that the undersides of the arches could just be seen and this was useful in delineating its form against the pale grassy background. The rich colours of the trees and bushes called for the application of strong washes, to provide

Dry brushwork suggests texturing on the weathered stone of the old bridge.

tonal contrast with the pale sky and river bank. The fringe of foreground grass on the left needed painting in deep tones to make it register against a stretch of pale water and help provide compositional balance.

Try to visualize your chosen subject in watercolour terms and use your initial sketch to work out your tone values.

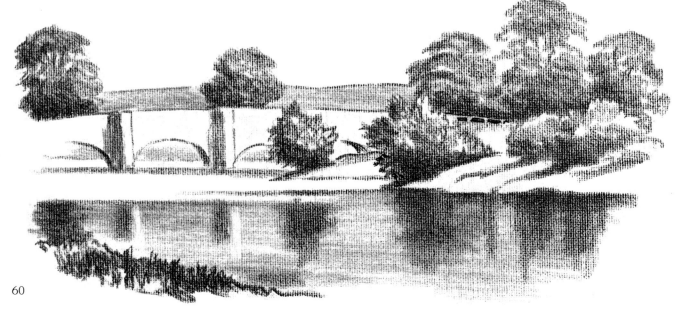

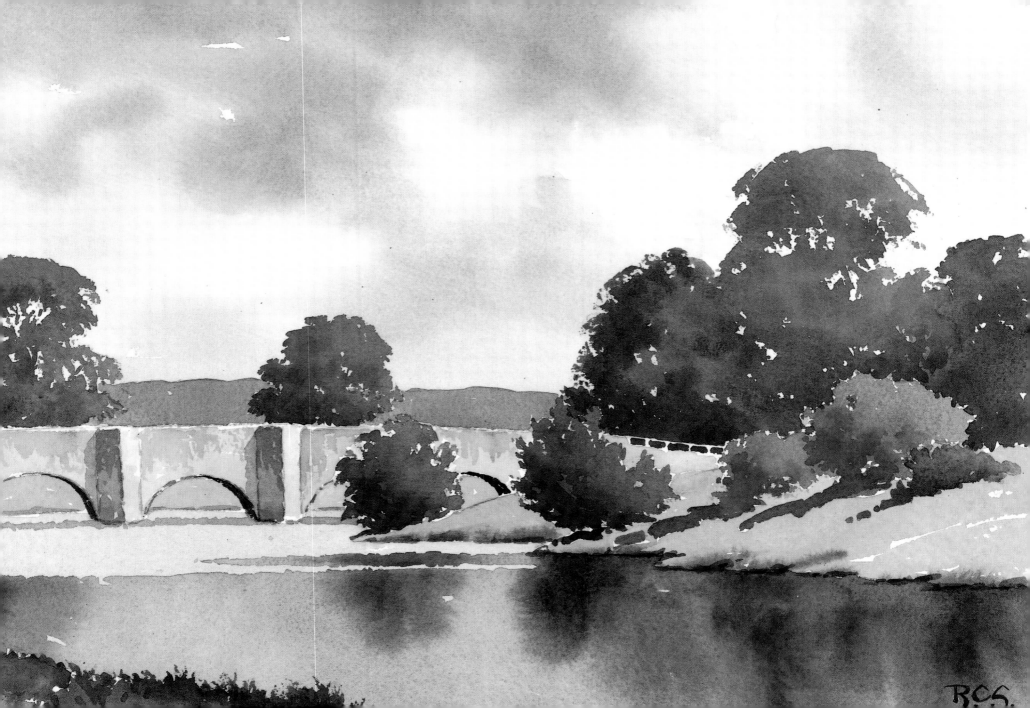

3 TOWN AND VILLAGE

OUNTRY cottages, mellow farm buildings and stately homes all offer painters wonderful opportunities to use their skills, and the summer activities of many art clubs confirm the popularity of such subjects. There is nothing wrong with this and it is as well that the shrinking countryside, with its rich heritage of traditional buildings, should be recorded while there is still time. Those forced to live or work in or near large towns often prefer to hang rural and village landscapes on their walls, partly for aesthetic and partly for nostalgic reasons. A preoccupation with the rustic and the picturesque, however, may blind us to possibilities nearer home.

Inner cities and industrial landscapes have an appeal of their own for the artist with an open mind and eyes to recognize their potential. In this chapter I look at both urban and village material and include paintings of such unlikely subjects as railway sidings and mine workings. If you have not tried your hand at such scenes, these paintings may suggest to you ways in which they could be tackled.

I used Karisma water-soluble graphite pencils for the preliminary sketches in this chapter. These enable marks to be softened and blended with a moist brush to produce a variety of effects.

(Opposite) *Tower Bridge, London*

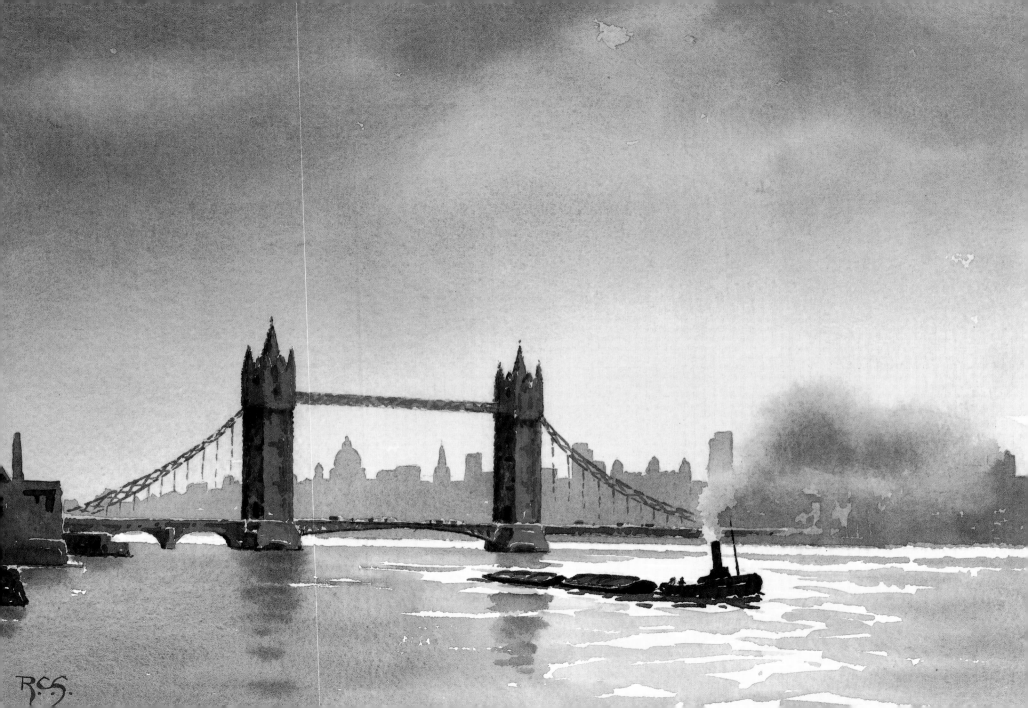

The Country Church

PALETTE

raw sienna
burnt sienna
light red
French ultramarine
Winsor blue

PAPER

Saunders 300lb
(640gsm) Not

BRUSHES

1in (2.5cm) flat,
No.12, No.10, No.8
Sceptre rounds

I TOOK a group of students to this pleasantly secluded hamlet. We had been discussing composition earlier in the day and I was glad to see they spent plenty of time studying and sketching the scene from several angles before making up their minds about the most satisfactory composition. There were a number of possible solutions, but this view was the most popular and probably the best.

Many valid reasons were given for the choice of this view of the church at a slightly oblique angle. It is not only more interesting than a head-on view would have been, but

My first sketch worked quite well and would have made a satisfactory painting, with some cloud shadow on the right to provide tonal balance.

The final sketch.

enables both sunlit and shadowed elevations to be seen. There is, too, plenty of tonal contrast, for example the church tower and gravestones against the dark background of trees. The church spire, the dominant feature, is placed well off-centre, and is balanced by the nearer building on the right. The expanse of foreground drive broken by the cast shadows, leads the eye into the painting, but not out of it; and the long line of stone retaining wall is broken by the white signpost, the small tree and the bushes.

In my second sketch the arrangement is too 'square-on' for a pleasing composition.

Do not try to paint every detail of a nearby stone wall – a few random blocks will suggest the material and will look more spontaneous.

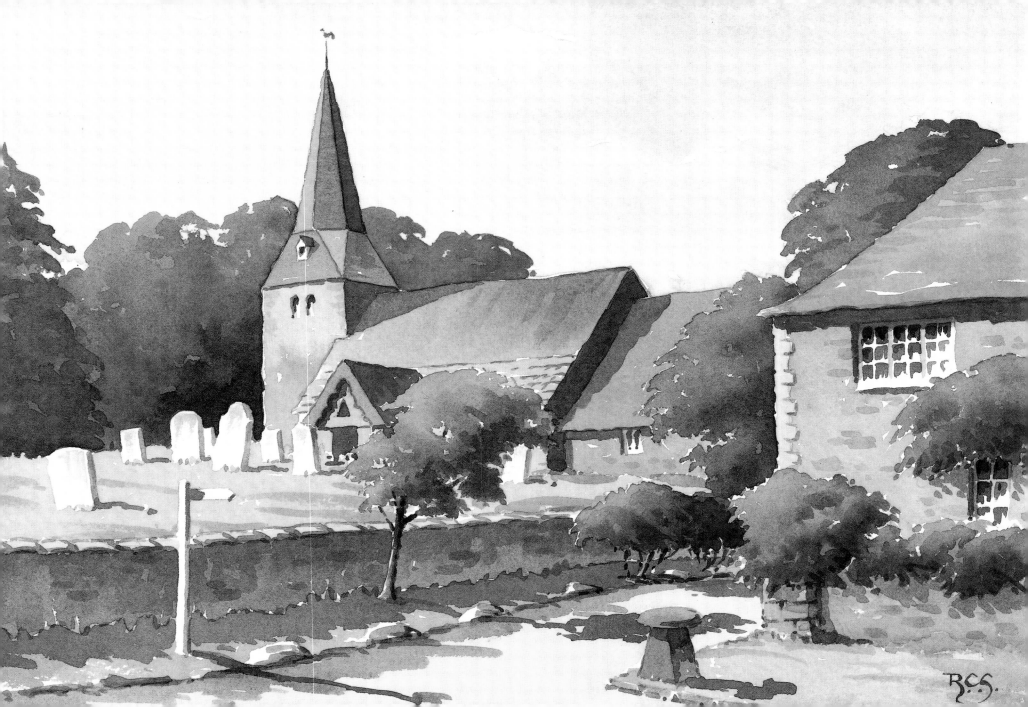

The Village

I MADE several sketches of this peaceful village from a variety of viewpoints but finally settled on this one. Here the cottages overlapped to some extent and so related to one another; the winding road was prevented by the left-hand house from carrying the eye off the paper and the glimpse of the distant ridge made a pleasing backdrop. There is plenty of variety in the colour of the trees and bushes which provide useful tonal contrast with the buildings, while the lateral shadows on the left break up the uninterrupted expanse of road.

It was a fine, warm afternoon in late summer and the sky was just a pale, graded wash of Winsor blue and raw sienna at the top, shading into raw sienna with a touch of light red at the horizon. The old tile and brick of the cottages were varying combinations of burnt sienna and light red, and I added some broken washes to indicate weathering, making sure that these followed the sloping lines of the roofs. Sometimes a single, flat wash can look too smooth and bland for old materials and a suggestion of texture needs to be added.

Although in general terms it is better to say what you have to say in one wash rather than two or more, there are times when second washes are needed to denote texture.

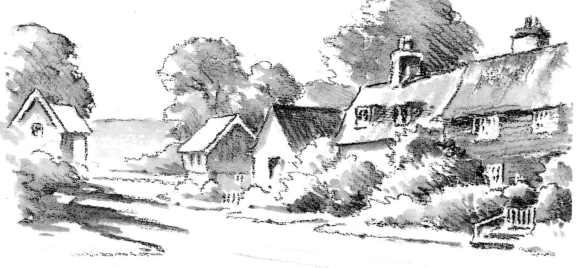

The lateral shadows break up the expanse of pale-toned roadway.

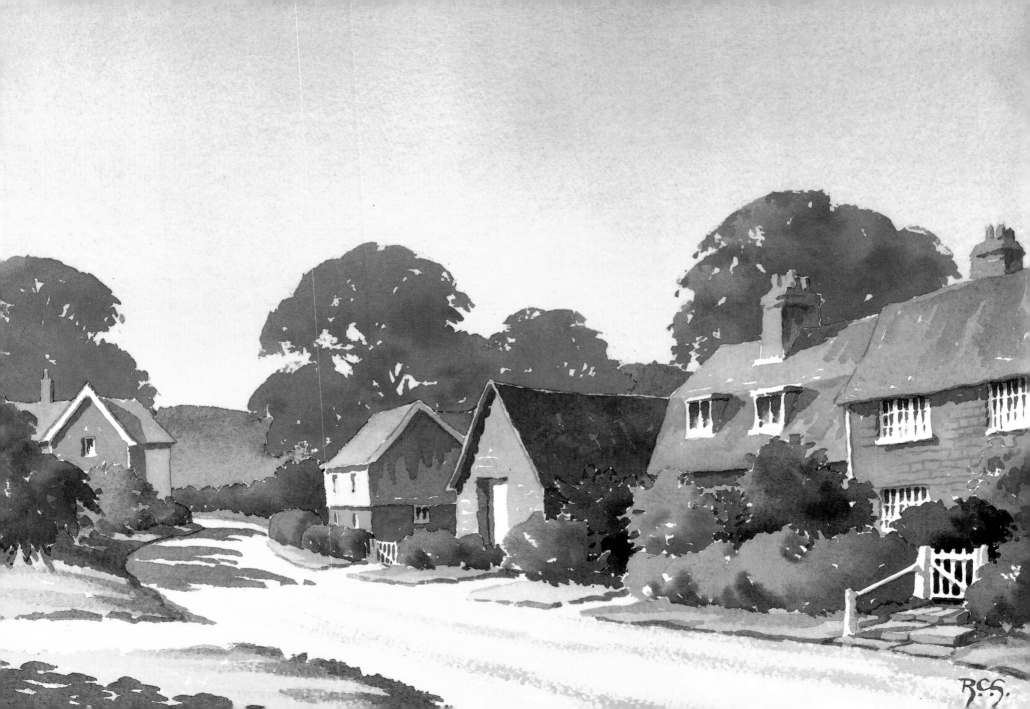

The Canal

PALETTE

raw sienna
burnt sienna
light red
French ultramarine
Winsor blue

PAPER

Arches 300lb
(640gsm) rough

BRUSHES

Two 1in (2.5cm) flats,
No.12, No.10 and No.8
Sceptre rounds

HERE is another urban scene in which there is plenty of form and colour to interest the painter. The composition works well with the deep-toned warehouse on the right balancing the jumble of buildings on the left. The odd angles and shapes of these overlapping forms relate well with one another, while the strong verticals of church spire and chimney stacks act as foils to the mainly horizontal lines of the other elements of the painting. There is plenty of tonal contrast and this would photograph well in black and white, a sure test of the effectiveness of the tone values. Notice, for example, how the spire and chimneys stand out against the luminous expanse of sky and the foreground railings against the pale stretch of smooth water.

In a painting where a certain family of colours predominates, the inclusion of a small area of complementary (or opposite) colour can provide a crisp accent.

The band of cool green on the barge strikes a chord against the warm browns of the background.

Although the buildings and their reflections are mainly warm browns and greys, there is plenty of rich colour and I have made the most of the rusty corrugated iron of the shed roofs. The band of green on the side of the barge makes a telling accent against its background of mainly complementary colour.

Because there was plenty of crisp form and detail in the canalside buildings, I treated the sky and the water very smoothly for the sake of contrast and to provide areas of calm where the eye may come to rest.

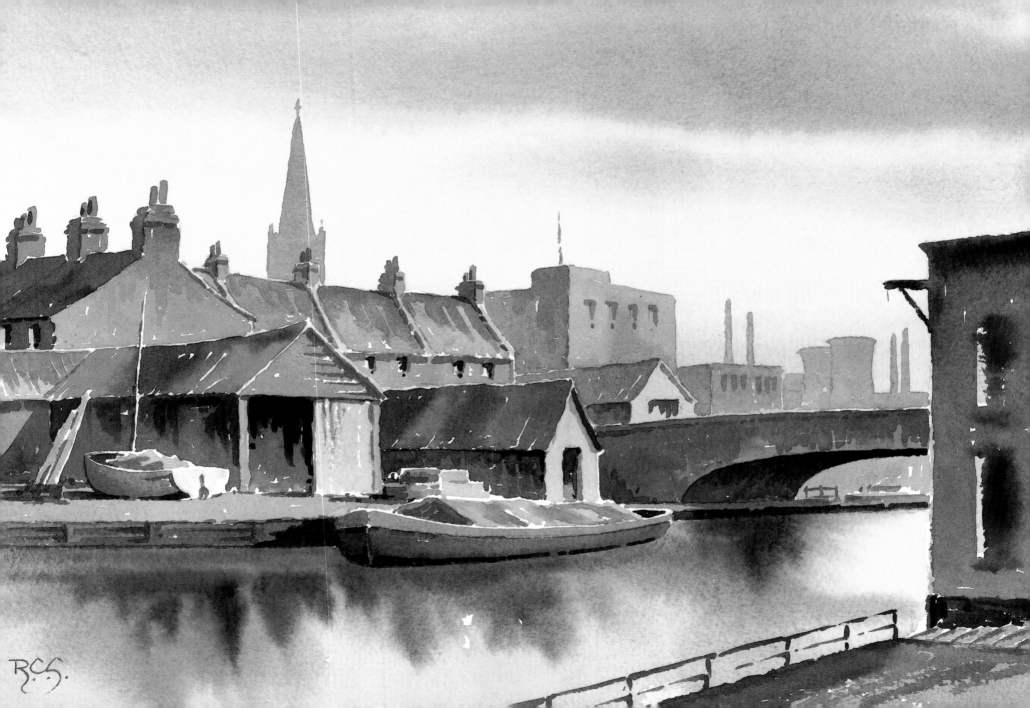

Adam and Eve Cottage

THE harbourside cottages of Cornwall have a form and character all their own. Their steep slopes and narrow alleyways, largely conditioned by the contours of the hard rock on which they stand, have a particular appeal to the artist. Of all the Cornish fishing villages, Polperro is among the richest in quaint old buildings, and delightful compositions appear at every turn. The group comprising Adam and Eve Cottage and the hostelry known as The Three Pilchards is among my favourites and this sketch shows it with the little alley running

PALETTE

raw sienna
burnt sienna
light red
french ultramarine
winsor blue
Payne's grey

PAPER

Saunders Waterford
300lb (640gsm) Not

BRUSHES

Two 1in (2.5cm) flats,
No.14 sable, No.10
and No.8 Sceptre
rounds

The stooped figure draws attention to the narrow alley-way between the old buildings.

down between the two buildings. The light was coming from the right, so the alleyway was in shade. There was, however, plenty of warm, reflected light to add colour and interest to the shadows and I placed a single figure against it to act as a focal point.

Because the composition was fairly complex, I kept the treatment of the sky as simple as possible, using a graded wash of

Winsor blue shading into raw sienna. I used full washes of pale raw sienna, with local warm and cool variations, for the rendered walls of the cottages and added texturing washes, applied with vertical strokes of a large brush, for the areas of weather staining. The local slates have an attractive greenish tinge for which I used Payne's grey with touches of raw and burnt sienna.

When painting rendered or colour-washed walls, always look for local colour and weather staining to add interest to flat surfaces.

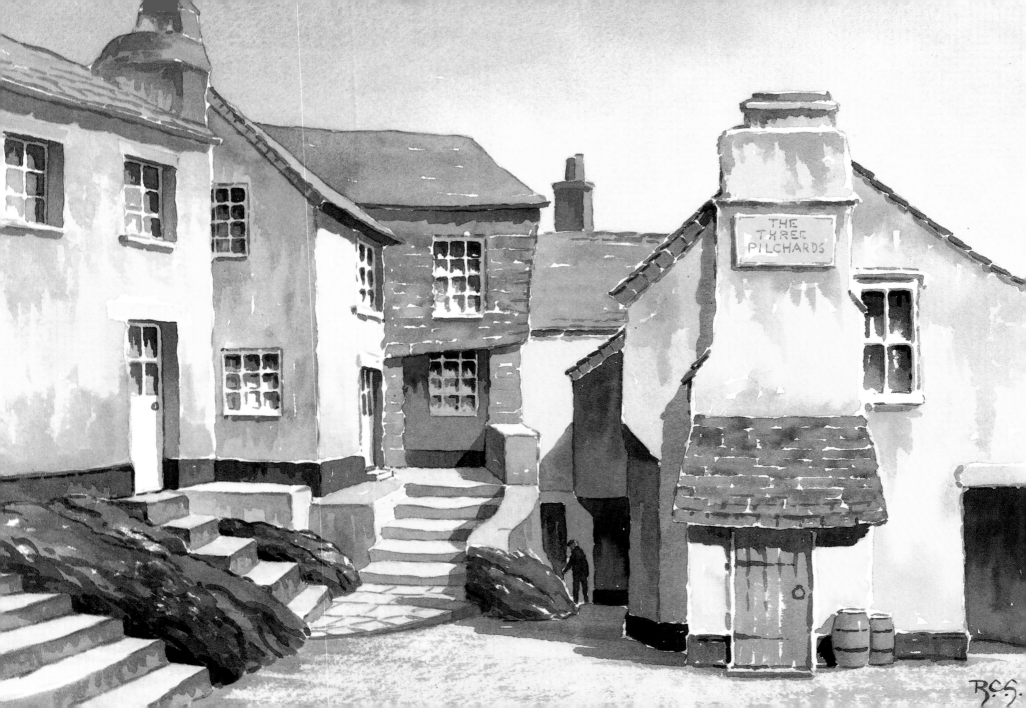

A Pit Head, Evening

PALETTE

raw sienna
burnt sienna
light red
French ultramarine

PAPER

Saunders Waterford
300lb (640gsm) Not

BRUSHES

1in (2.5cm) flat,
No.14 sable, No.12,
No.10 and No.8
Sceptre rounds

THE stark lines of industrial installations often provide interesting and even dramatic subject matter and are well worth the consideration of painters eager to extend their range. Although there is nothing intrinsically appealing about this rather grim coal-mining scene, and those who prefer the gentler moods of nature would not even consider it, it has, to my mind, a richness of form and colour that makes it a fitting and challenging subject. The pit shaft and slag heaps make strong statements against the amber sky which is vividly reflected in the stretch of foreground water. It makes a well-balanced composition with the dominant feature, the pit shaft, not far from the golden mean.

Subjects such as this are often seen at their best when bathed in a strong or even lurid evening light. I therefore applied a wash of raw sienna to the whole paper, warming it a little with light red for the area of the lower sky. While the paper was still wet I added the clouds with a warm blend of light red and French ultramarine applied with quick, horizontal strokes of a large brush so that their soft outlines would contrast with the crisper treatment of the scene below. The same mixture served for the line of distant hills and I used ever stronger colour and

A subject such as this can look more dramatic in a warm, evening light.

contrast as I worked towards the foreground in order to make it come forward convincingly. I made the most of the rich colours of such material as rusty corrugated iron and left chips of light where some of the horizontal forms were caught by the evening glow.

The reflection of a glowing sky can often provide a telling accent in the foreground.

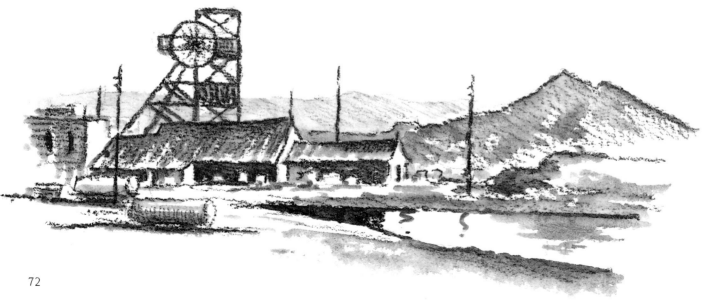

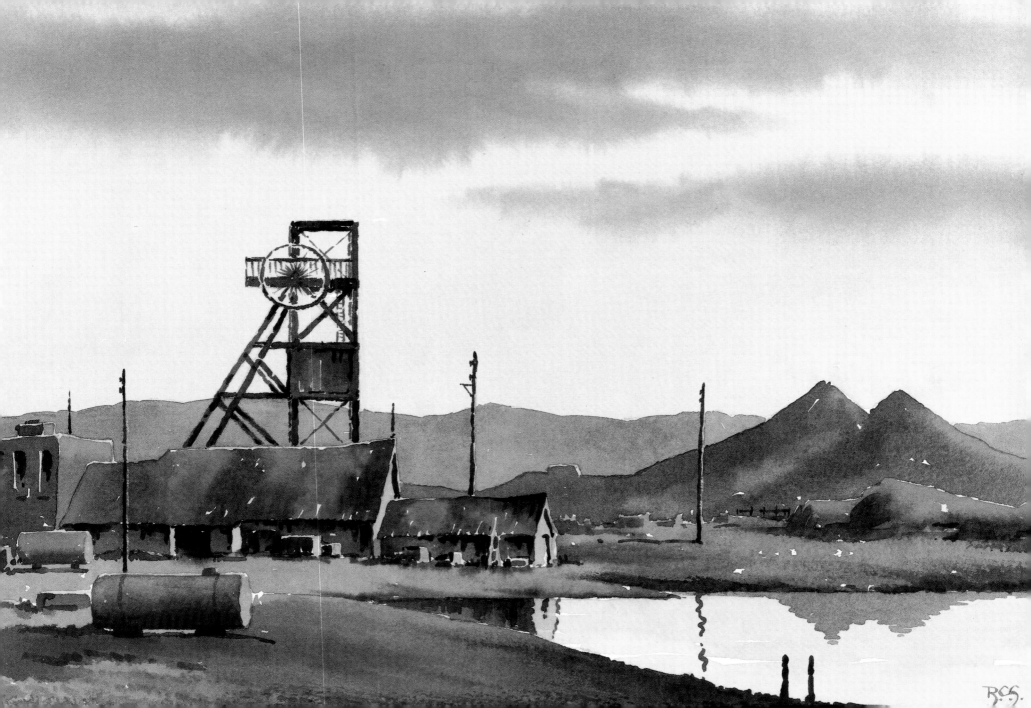

The Old Farmhouse

Aᴸᴛʜᴏᴜɢʜ I normally prefer to tackle farming subjects with groups of barns, byres, outhouses and sheds combining to form interesting compositions, this wonderful old farmhouse seemed to merit individual attention. Like many old buildings of its kind, it has been added to many times in its long history and its medley of unplanned additions and variety of styles add to its charm. With a subject such as this, it is not only a matter of finding the best viewpoint; important though that is, it is also necessary to ensure the light is coming from the right quarter, so that the various elevations and

PALETTE

raw sienna
burnt sienna
light red
French ultramarine
Winsor blue

PAPER

Arches 300lb
(640gsm) rough

BRUSHES

1in (2.5cm) flat,
No.14 sable,
No.10 and No.8
Sceptre rounds

Remember to indicate moss and algae on old masonry and tiles.

features are enhanced by the play of light and shade. Light coming over my right shoulder would have produced no visible shadow, except for that cast by the small tree. With the light shining obliquely from the left, the areas of sunlight and shadow are roughly the same and this is extremely helpful in giving the subject a three-dimensional look and in adding extra interest.

I kept the sky very simple so that it would not compete with the complex forms below –

just a pale wash of Winsor blue with a little raw sienna added lower down, and a few chips of white left for the summery clouds. The sunlit tiles and brick walls were mainly burnt sienna and light red with the addition of a little green to suggest moss and algae, with stronger washes including French ultramarine for the shadowed elevations. Because the subject was very close, I included more indication than usual of the building material detail without resorting to painting every brick and tile.

The angle of the light can make a deal of difference to the effectiveness of a painting of buildings. Make sure the sun is in the optimum position before you record areas of light and shade.

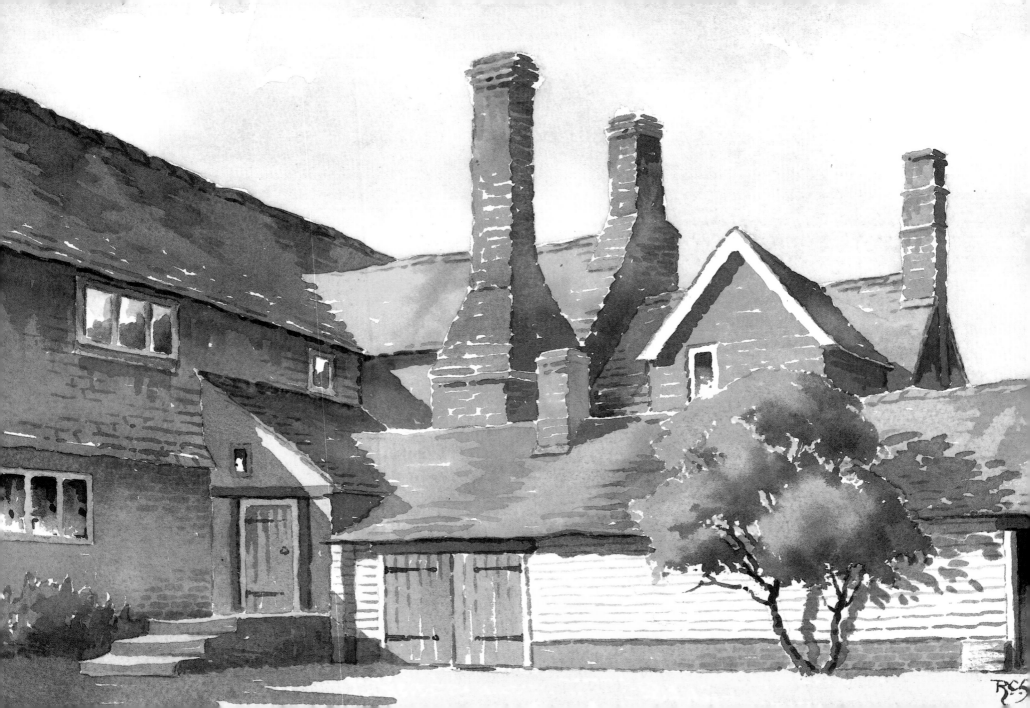

After the Rush Hour

PALETTE

raw sienna
light red
French ultramarine

PAPER

Arches 300lb
(640gsm) rough

BRUSHES

Three 1in (2.5cm) flats,
No.12, No.10 and No.8
Sceptre rounds

NOT the sort of scene you would want to hang on the wall of your living room, perhaps, particularly if you are a rail commuter, but, for all that, a subject full of feeling and atmosphere. Once again I have made use of a warm and misty evening light to add to the mood of the deserted stretch of permanent way. The converging lines of the railway tracks are soon swallowed up in the murk and this adds to the feeling of mystery.

I decided to establish the mood with a single variegated wash over the whole paper, preserving the rails and the strip lights with masking fluid. I prepared three washes: light red with a little French ultramarine for the soft clouds and the foreground, raw sienna and light red for the glowing sky and French ultramarine with a little light red for the misty area behind the signal gantry. I applied these quickly with three large brushes so that they merged together and, while the paper was still moist, I painted the plume of smoke, wet in wet, with a little of the first wash.

I then let everything dry, removed the masking fluid and painted the rails to reflect the glow in the sky. A warm grey wash, for the silhouette of the buildings and factory

In misty conditions, distant buildings can often be effectively suggested in silhouette by a single pale grey wash.

chimneys, went in next and I carried this down to the foreground huts but blended it into the background on the left with pure water. I used stronger combinations of light red and French ultramarine for the huts, the sleepers, the light standards and the signals, finally adding still stronger accents here and there for greater contrast.

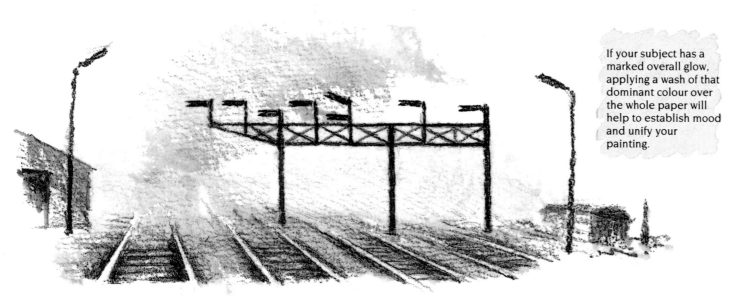

If your subject has a marked overall glow, applying a wash of that dominant colour over the whole paper will help to establish mood and unify your painting.

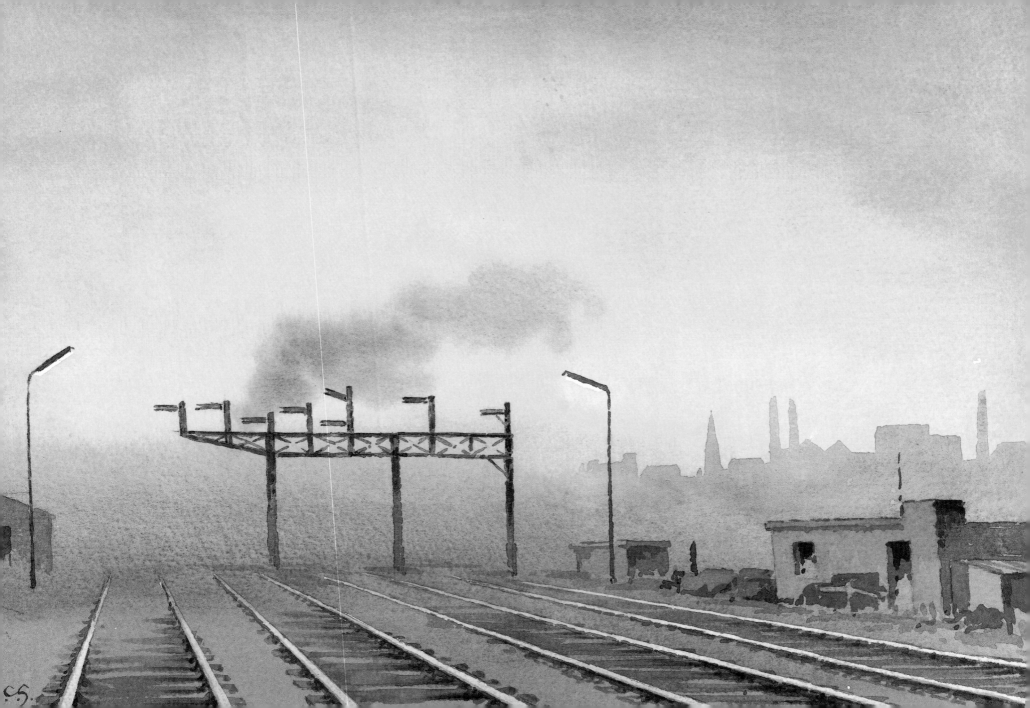

A Quiet Smoke

HERE is another urban study in which I have used just three colours to establish the warm but murky atmosphere of a foggy evening in London. The subject is an old GWR locomotive, with steam up for shunting duties, waiting by some engine sheds. The vertical plume of smoke and the pale cloud of escaping steam play their part in enhancing the mood of the scene.

The rails reflect the warm light of the evening sky and lead the eye straight to the

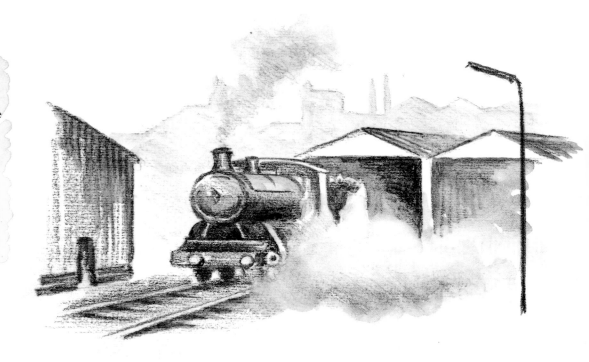

The liberal use of the wet in wet technique can help you capture the effects of smoke and steam.

locomotive. The strong vertical of the light standard ties the various elements of the painting together and helps to balance the main weight of the composition on the left.

I applied masking fluid for the strip light before flooding a liquid wash of raw sienna and light red over the whole paper. While it was still wet I added a little light red and French ultramarine for the upper sky and some clear water to lighten the cloud of steam. Once the paper was dry I applied a wash of light red and French ultramarine for the warm grey silhouette of the distant buildings, painting carefully round the outline of the locomotive to preserve its highlights. I then applied masking fluid to the rails and put in the buildings and the foreground fairly loosely, softening the washes with clear water as they approached the cloud of steam. The locomotive went in last in very deep tones and with rather more precision.

It helps to direct attention to a crisply painted focal point if the rest of the scene is more loosely handled.

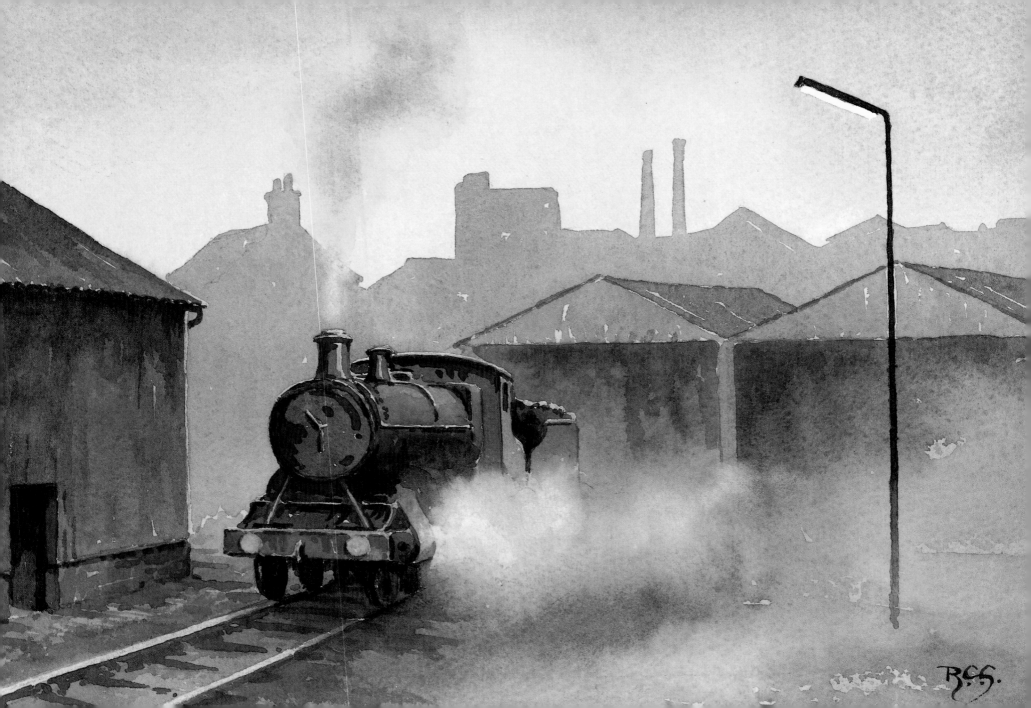

Village Buildings

I CAME upon this group of Cotswold buildings one bright morning in late summer and made a number of quick sketches of which this one looked the most promising. The little river was very low after a spell of drought and I indulged in some artistic licence to replenish its waters so that they might accommodate some interesting reflections. I also moved a sizeable oak tree several hundred yards to provide some compositional balance for the houses on the left. The distant shoulder of hill was in shadow and provided some useful tonal contrast with the sunlit buildings.

I established the cloudy sky in one

PALETTE

raw sienna
burnt sienna
light red
French ultramarine
Winsor blue

PAPER

Arches 300lb
(640gsm) rough

BRUSHES

Three 1in (2.5cm) flats,
No.14 sable,
No.12 and No.8
Sceptre rounds

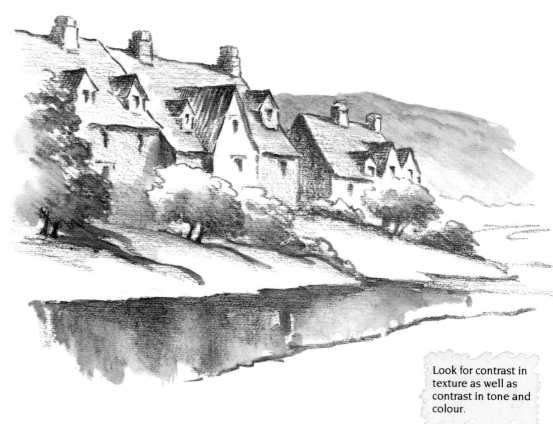

Look for contrast in texture as well as contrast in tone and colour.

When adding texture to roofs, the brushwork should follow the line of the roof.

operation, using three large brushes and three liquid washes for the sunlit clouds, the cloud shadows and the small patch of blue sky. The blue-grey distance was a wash of French ultramarine with a little light red and I later added a hint of trees and hedges with a slightly deeper wash of the same two colours.

There was not a great deal of colour in the honey-hued stone houses, so I made the most of the areas of greenish moss and weather-staining, and also exaggerated the diversity of autumnal tints of the trees and bushes below. The reflections in the river were painted wet in wet to produce a soft-edged effect. I finally added some dry brush-work to the foreground field to provide textural contrast with the smooth water.

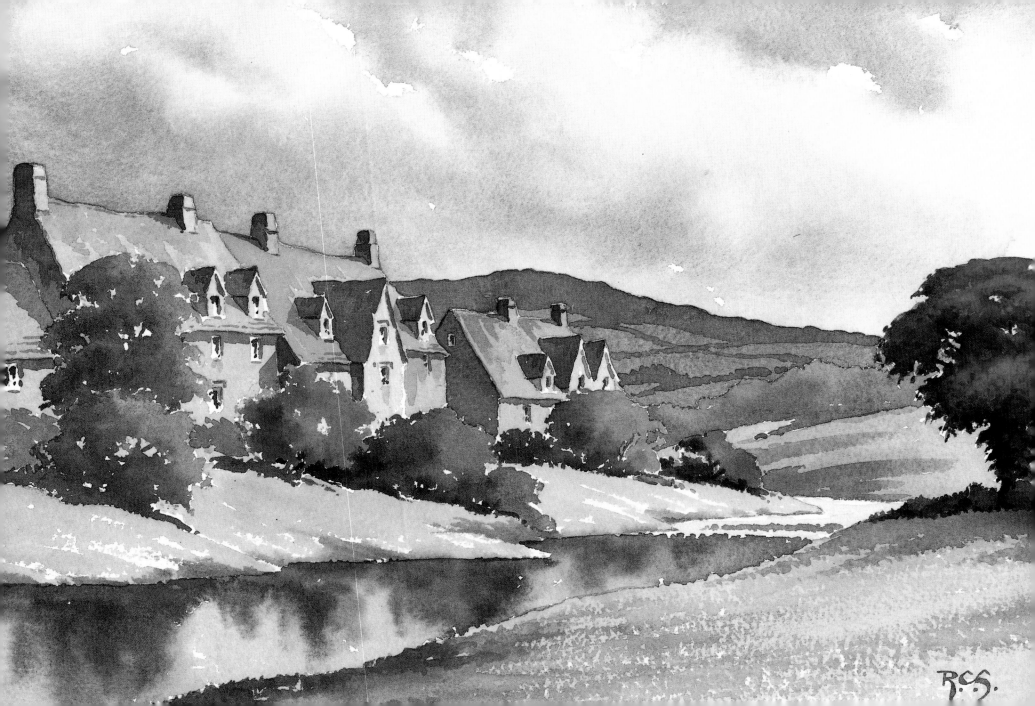

The Steel Works' Last Days

The closing of the large, long-established steel-producing works at Ravenscraig was a bitter blow to the area and a source of sadness for the whole of Scotland. In this impression of the complex during its final run-down I aimed to capture something of the melancholy which pervaded the area at the time, with the fading evening light somehow reflecting the end of its long and industrious life.

The sketch shows only a small part of the works and I decided to include a broader

PALETTE

raw sienna
burnt sienna
light red
French ultramarine

PAPER

Saunders Waterford
300lb (640gsm) rough

BRUSHES

1in (2.5cm) flat,
No.14 sable,
No.12, No.10
and No.8 Sceptre
rounds

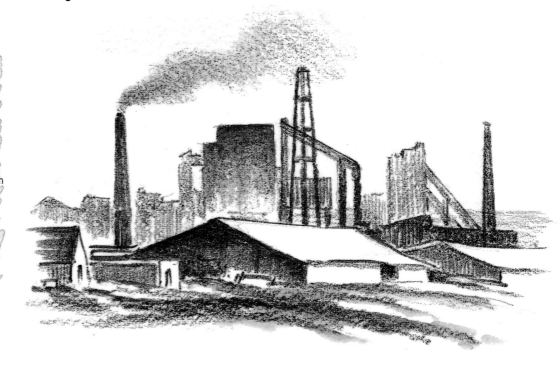

In an industrial complex such as this, a great deal of simplification is necessary but a strong impression of the installations should remain.

sweep in my painting. The buildings and machinery were amazingly complex and I have attempted to convey only a rough impression of the industrial panorama. Not all the furnaces had been shut down and a few plumes of smoke and steam were still to be seen. The factory chimneys and other verticals helped to link the sky to the scene below and also made dramatic statements in their own right. I increased the extent of the foreground water to make the most of the vivid reflections and these, too, helped the relationship between land and sky.

I began the painting by applying a pale wash of raw and burnt sienna to the whole paper, adding a mixture of light red and French ultramarine, wet in wet, for the clouds and the smoke. I used a slightly deeper version of the same warm grey for the distant buildings and this I applied in a single wash. The nearer buildings and plant were painted with stronger colour and greater tonal contrast, to bring them forward. The foreground went in very roughly and for once I used body colour – but only to paint in my initials!

Do all you can, by means of reflections, to link the sky to the scene below.

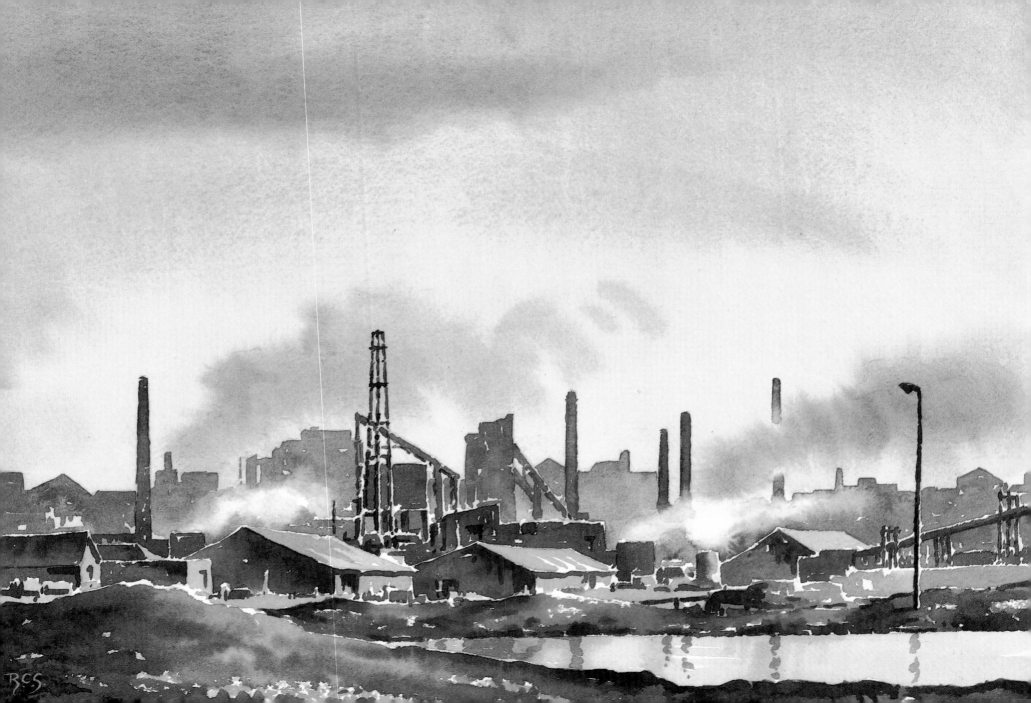

4 HOLIDAY SCENES

I N THIS chapter I include paintings made in France, Italy, Greece and Malta. Watercolour is an effective medium and many are the conversations I have had with interested locals – frequently painters themselves – who seemed surprised and impressed with its strength and versatility. The language of art is international and has a way of breaking down barriers.

I find my limited palette works well for most North European landscapes, but as one travels south, the colours become stronger and more intense and that is the time to call up reinforcements. I find that French ultramarine and Winsor blue are equal to the challenge, but brighter yellows, oranges and reds are required and for these I use the cadmiums.

Another problem we have to face is speed of drying in these hot, sunny conditions. The best solution is the obvious one of increasing slightly the amount of water in each wash, and this soon becomes second nature. An alternative solution is to add a few drops of glycerine to the water jar, but the disadvantage here is that *every* wash will dry more slowly, including those that present no difficulty.

I have used Indian ink for all the preliminary sketches, applied with pen or brush or both.

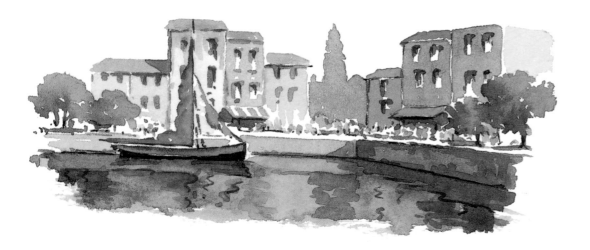

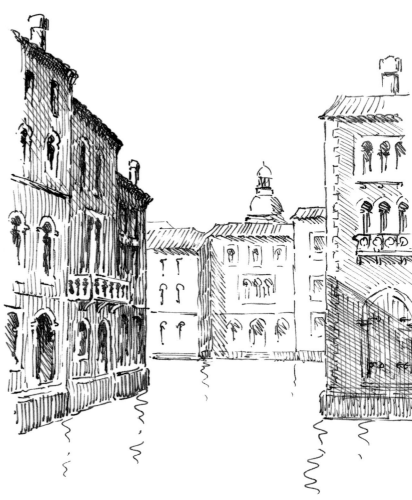

(Opposite) *Sunshine and Shadow, Venice.*

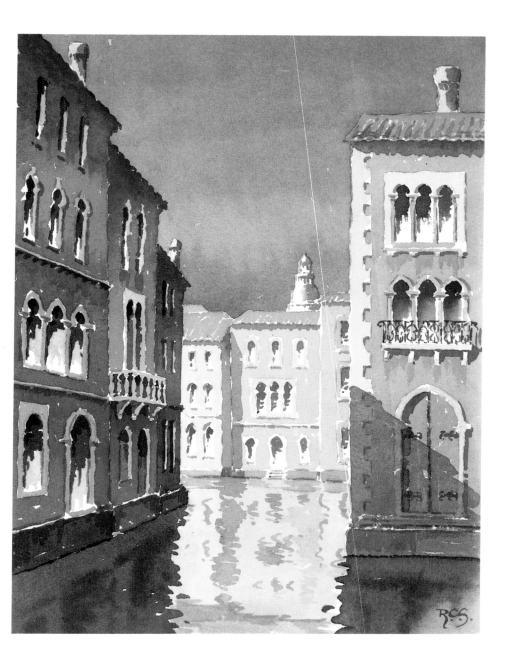

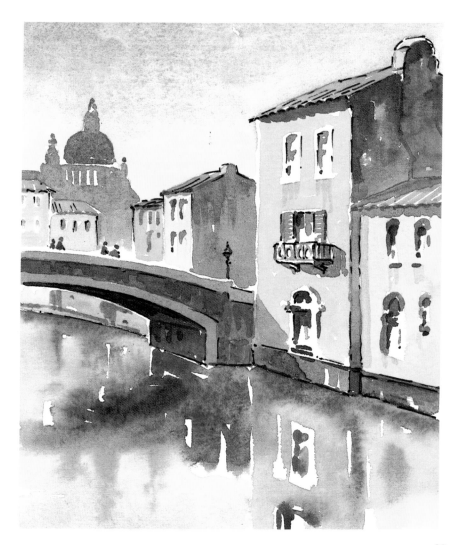

A Street Corner, Tuscany

PALETTE

raw sienna
burnt sienna
light red
French ultramarine
Winsor blue

PAPER

Bockingford 200lb
(425gsm)

BRUSHES

Two 1in (2.5cm) flats,
No.14 sable,
No.10 and No.8
Sceptre rounds

The final sketch.

Fascinating old villages abound in the Italian province of Tuscany and the artist is spoiled for choice. With intriguing vistas at every turn, I finally decided to base my painting on this particular sketch for a number of reasons. I liked the way in which the road leads the eye towards the focal point – the little church – which is placed off-centre to the left; there is good compositional balance, an interesting interplay of light and shade and an abundance of tonal contrast. In sunny scenes, such as this, one should make a conscious effort to include plenty of shadow, or the result can easily look flat. Notice how the pale figures on the right have been placed against a background of shadow while those on the left appear deep-toned against a patch of sunlight. There is rather too much foreground road for comfort but this has been effectively broken up by the

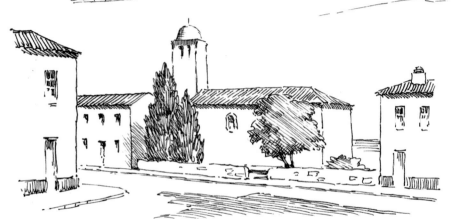

I liked this grouping of the village buildings, but the church tower – a useful focal point – was out of the picture to the left.

shadows of the solid stone gateway and some houses off the painting to the right.

The sky was a variegated wash of French ultramarine merging softly into pale raw sienna. The sunlit walls of the colour-washed houses were raw and burnt sienna washes of varying strengths and on some I added evidence of weathering with broken washes of deeper tone. The shadows were mainly light red and French ultramarine to which I added burnt sienna for the rich glow of warm reflected light.

A rather linear arrangement, with not much tonal contrast to give it a three-dimensional look.

Shadows add interest and variety to featureless areas. Make the most of them!

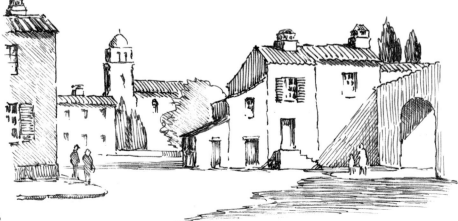

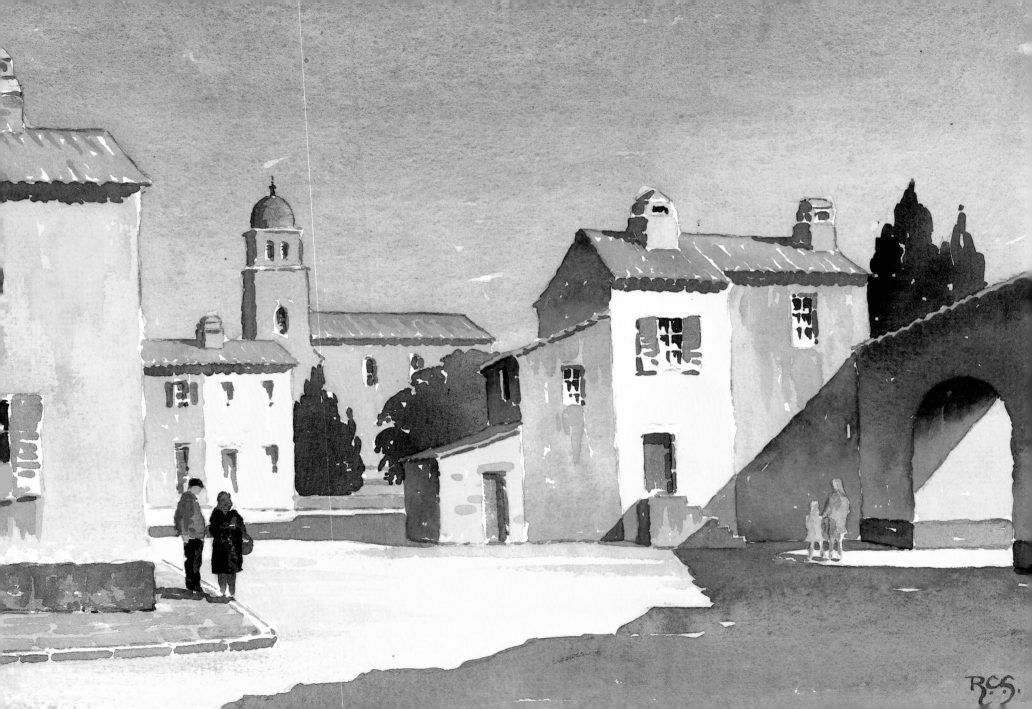

Market Day in Provence

PALETTE

cadmium yellow
cadmium red
raw sienna
burnt sienna
light red
French ultramarine
Winsor blue

PAPER

Arches 300lb
(640gsm) rough

BRUSHES

1in (2.5cm) flat,
No.14 sable, No.10,
No.8 Sceptre rounds

THE warmth and colour of a typical Provençal market scene provide the artist with a wealth of attractive subject matter. I made several quick sketches of various aspects of the scene, but finally chose this one for three main reasons. The flower stall and the fruit shop in the foreground provided plenty of glowing colour and useful compositional balance. They also framed the glimpse of the bustling market square beyond. The strong lateral shadows in the foreground and the line of middle distance stalls both helped to tie the two halves of the subject together.

I decided upon a very simple sky to provide a restful area to contrast with the busy scene below, and applied a pale, variegated wash of Winsor blue softly merging into raw sienna and light red. The distant houses were very broadly suggested, with plenty of pale grey added to their local colour to aid recession, and the middle distance stalls and shoppers were dealt with in an equally loose manner. The nearer figures were put in with free brushstrokes in stronger colours and I concentrated more on posture than on detail. The contrast in tone between the mid-ground figures and the distant houses is highlighted in the detail.

I used plenty of rich colour for the flower

The figures have been economically suggested, with posture more important than detail.

Some subjects demand figures; even if you have difficulty with the human form, you will get by provided you concentrate on posture.

stall on the right and made sure the warm glow cast by the red umbrella was reflected on the objects below. The fruit on the left of the painting provided another opportunity for using lively colour. I placed the two figures against dark backgrounds to provide tonal contrast. As you will see by comparing the initial sketch with the finished painting, the little girl and her dog were an afterthought to give additional human interest and further help in linking both sides of the painting.

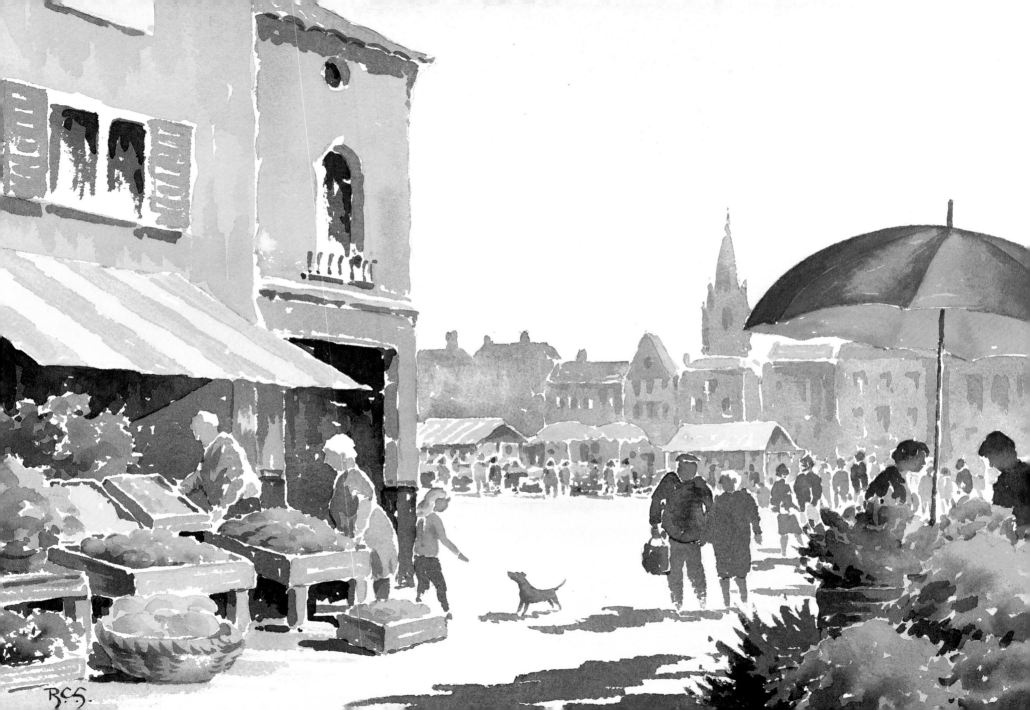

Santa Maria Della Salute, Venice

THIS scene has been painted so many times that in some people's opinion it has become hackneyed – but not in mine! Provided you make an honest attempt to say something personal about a subject and do not merely try to imitate what someone else has done it matters not how many artists have been there before.

The strong treatment of the gondolas and mooring posts makes the pale line of buildings recede.

PALETTE

raw sienna
light red
French ultramarine
Payne's grey

PAPER

Bockingford 200lb
(425gsm)

BRUSHES

Two 1in (2.5cm) flats,
No.14 sable,
No.10 Sceptre
round

The light in Venice really is something special, as every visiting painter will testify, and it is this which helps to give the city its unique magic. The day on which I painted this scene was cloudy, yet there was a misty radiance in the sky which I was determined to try to capture. Tonal sketches, such as the one above, can be a useful way to check composition and to give you clues about the relative 'importance' of different parts of the painting. However, in this instance I waded in without any preliminary drawing or sketching before the light could change. I first applied a very pale wash of raw sienna with a touch of light red over the whole of the paper, and while this was still wet I dropped in mixes of French ultramarine and light red for the lower clouds, adding some Payne's grey for the cooler clouds above. A paler version of the warm grey served for the soft reflections in the water and this I applied, wet in wet, with vertical strokes of a large brush. I then left everything to dry.

If the light conditions are perfect, capture them while you can – other matters can wait!

I then prepared deeper washes of the same two greys and applied them with a No.10 brush, alternating between the warm and the cool, to add a little colour interest to the distant line of buildings, later adding a few darker accents. The moored gondolas and mooring poles went in last in very deep tones, to make them come forward and the lighter-toned buildings recede.

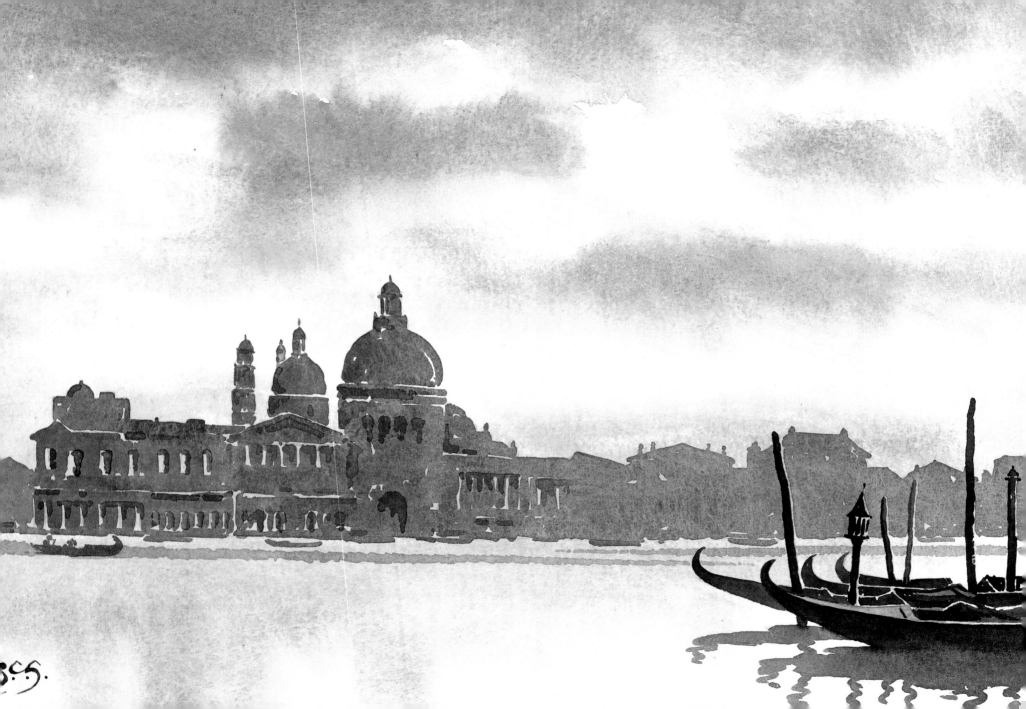

The Grand Harbour, Valletta, Malta

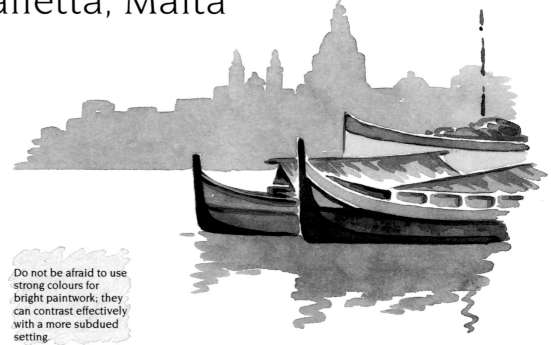

PALETTE

cadmium yellow
cadmium orange
raw sienna
burnt sienna
light red
alizarin crimson
French ultramarine
Winsor blue

PAPER

Arches 300lb
(640gsm) rough

BRUSHES

Two 1in (2.5cm) flats,
No.14 sable, No.10,
No.8 Sceptre rounds

THESE gaily painted boats with their steep prows are peculiar to Malta. Here they strike a vibrant note against the quiet tones and colours of the background. The quick monochrome impression (right), made with a brush dipped in diluted Indian ink, does not provide a balanced composition, so in my painting I added the stern of another boat in the foreground and a larger boat in the middle distance.

The buildings were too close to be treated as a flat, grey silhouette as in the sketch, so I

Do not be afraid to use strong colours for bright paintwork; they can contrast effectively with a more subdued setting.

The distant domes and spires have been very simply treated in pale tones so that they do not compete with the gaily painted foreground boats.

introduced an impression of the interplay of sunlight and shadow. This added considerably to their interest, as can be seen in the enlarged detail. The day was extremely hot, and although the sky was clear it had a heavy, almost thunderous look which called for the use of light red and a little alizarin crimson to be added to the French ultramarine. The calm water of the harbour was lighter in tone than the sky, a phenomenon that is hard to explain, but frequently occurs.

The sunlit buildings were painted mainly in raw sienna, with light red and a touch of

French ultramarine added here and there to provide texture, while stronger washes of the last two colours served for the shadowed elevations, with burnt sienna added to suggest warm, reflected light. For the bright paintwork of the foreground boats I used pure French ultramarine; Winsor blue and cadmium yellow in two different proportions; and cadmium orange with a little light red.

The reflections were clear-cut, their broken outlines being conditioned by the smoothly rippling surface of the water. The colours within the reflections were soft-edged, and were paler, muted versions of those above.

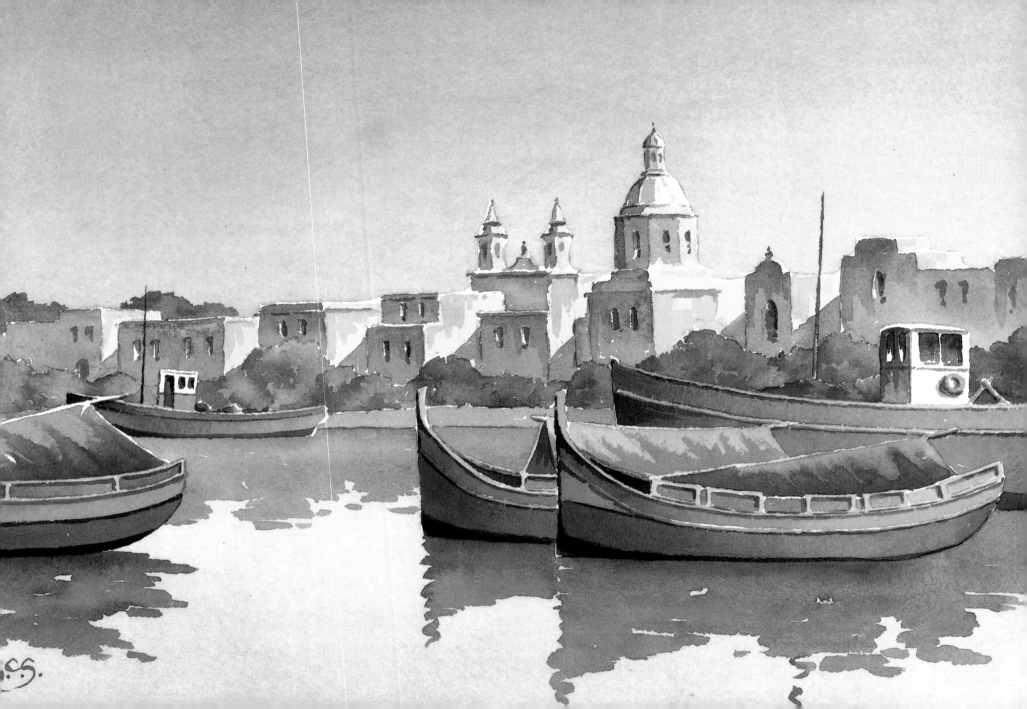

Mont St Michel, France

THIS rocky island off the French coast, a larger and more impressive version of St Michael's Mount in Britain, is a lovely subject for the watercolourist. On the day of my visit there were intermittent gleams of sunshine and a lot of dark cloud so I decided to make the most of these conditions to produce a dramatic impression. To this end I placed the mount against a luminous area of sky and emphasized its deep-toned shadows. I put in some heavy clouds above and achieved tonal balance by adding some dark,

> Complex detail can be suggested by loose brushwork – meticulous precision is not necessary.

PALETTE

raw sienna
burnt sienna
light red
French ultramarine
Winsor blue
Payne's grey

PAPER

Arches 300lb
(640gsm) rough

BRUSHES

Two 1in (2.5cm) flats,
No.14 sable, No.10,
No.8 Sceptre rounds

The deeply shadowed side of the mount has been placed against a patch of pale sky for the sake of tonal contrast.

weed-covered rocks in the left foreground.

This is the sort of subject with which it is all too easy to get bogged down in detail. A certain amount is necessary if there is to be a convincing impression of the subject, but I determined to keep the treatment fairly loose and avoid too much precision. I painted the individual buildings using only a few strokes each, as can be seen in the detail.

I began with the sky and applied a very pale wash of raw sienna over the whole area, dropping in a little French ultramarine and light red for the cloud shadows, and French ultramarine for the patch of blue sky. This looked a little tame on drying so I added a second wash of the same grey, softening it with pure water into the lighter areas of cloud, but leaving some hard edges.

The sunlit buildings and rocky outcrops were various pale combinations of raw sienna, burnt sienna, light red and French ultramarine, while a very strong mixture of the last two colours took care of the deep shadows. I used the same colours for the deep-toned reflections and a rich mixture of raw sienna, burnt sienna and Payne's grey for the foreground rocks.

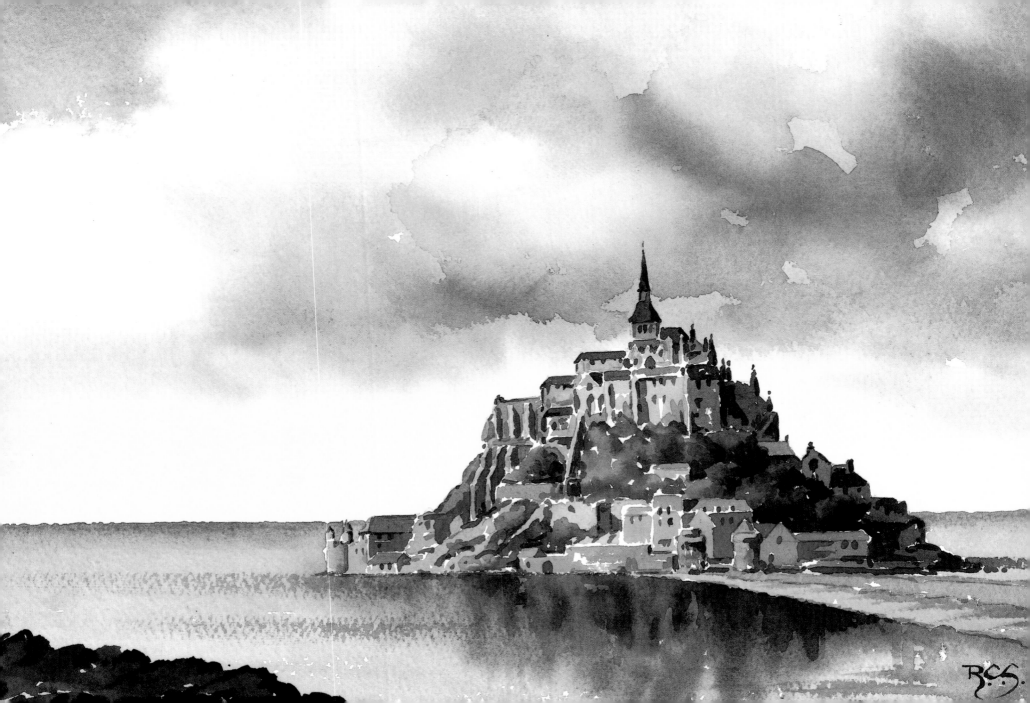

Roadside Café

THIS very loose black and white study was made, without any previous drawing, with a No.8 brush dipped in Indian ink. Although it lacks precision and leaves much to the imagination, it does convey a rough impression of the scene. It is a technique that forces you to study tone in order to produce recognizable images and although there is inevitably no tonal subtlety, this preoccupation with tone is a useful preliminary for a subject such as this in

PALETTE

cadmium yellow
cadmium red
raw sienna
burnt sienna
light red
French ultramarine
Winsor blue

PAPER

Arches 300lb
(640gsm) rough

BRUSHES

½in (1.3cm) flat,
No.14 sable, No.10,
No.8 Sceptre rounds

People do not always remain in position long enough to suit the artist. Gaps can usually be made good from a well-stocked sketch book.

which, without such discipline, the result could easily be a muddle.

In the finished painting I included more of the street, added a few extra figures and let the shadowed buildings on the left help to balance the main weight of the composition on the right. I altered some of the tone values, and several of the figures which appeared white against black in the sketch are now deep-toned against a paler background. There is still plenty of tonal contrast, however, and most of the figures register reasonably strongly. There is a certain amount of bright colour, notably in the café umbrellas, and this adds a touch of gaiety to the scene.

I think the finished painting has become a little tight and I may well have another shot at the subject using a looser technique more akin to that of the black and white study.

A loose monochrome study often helps you to sort out your tone relationships.

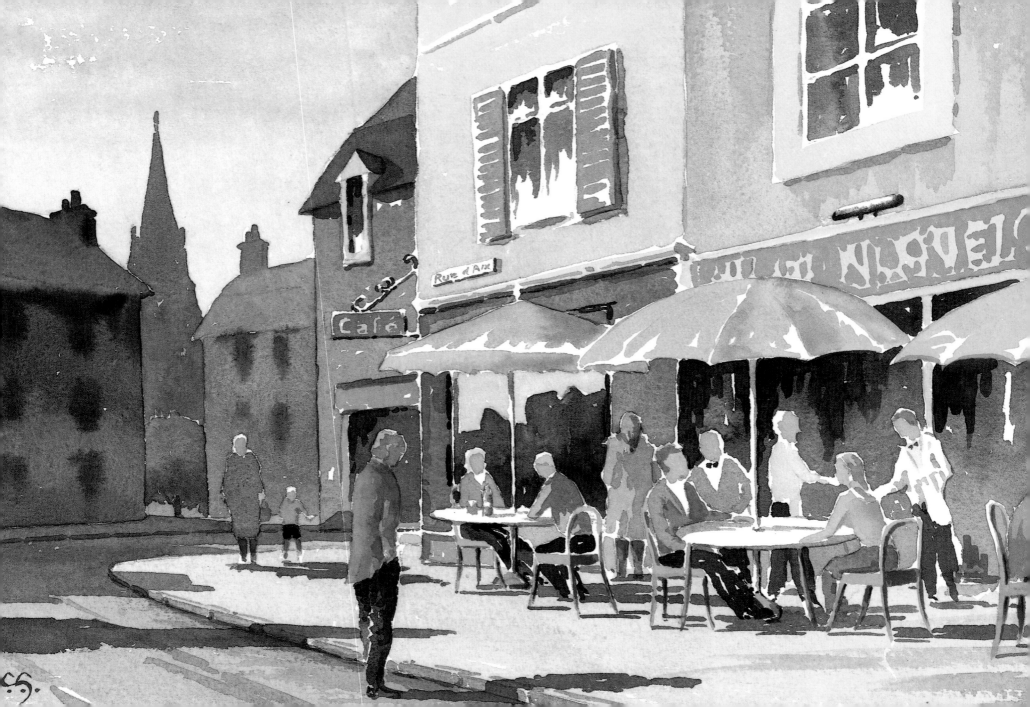

Gondolas, Venice

HERE is another Venetian study, but with very different colouring. The clear evening sky and the canal below were virtually the same colour and tone and were put in with a single variegated wash. I started at the top with pale Winsor blue, shading into raw sienna, then light red, then back again to raw sienna, and finally to Winsor blue at the bottom. A certain amount of each colour is carried into the next and this not only makes for softer blending but prevents the colours becoming too bright and garish. The paper was then allowed to dry.

The next step was to put in the line of distant buildings. Their warm colours were various combinations of raw sienna, burnt sienna and light red to which I added a little French ultramarine to aid recession. Slightly deeper accents were needed for shadows, doors and windows and for these I used a mixture of French ultramarine and light red.

All boats viewed at an angle need careful

Bold, loose brushwork was necessary if the painting was to be completed in the fading evening light.

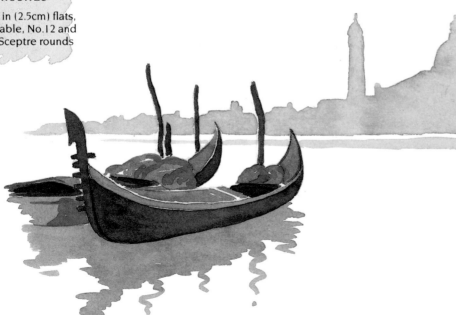

If you find your sky washes produce a stripy effect, try first moistening the paper evenly all over.

drawing and gondolas are no exception. Once I was satisfied with their shape, I painted them and the mooring poles in comparatively deep tones to make the group stand out boldly against the evening light and help to make the distant line of buildings recede. I remembered to indicate a little warm reflected light on the right hand hull and finally put in the greenish reflections with a wash of Payne's grey and raw sienna.

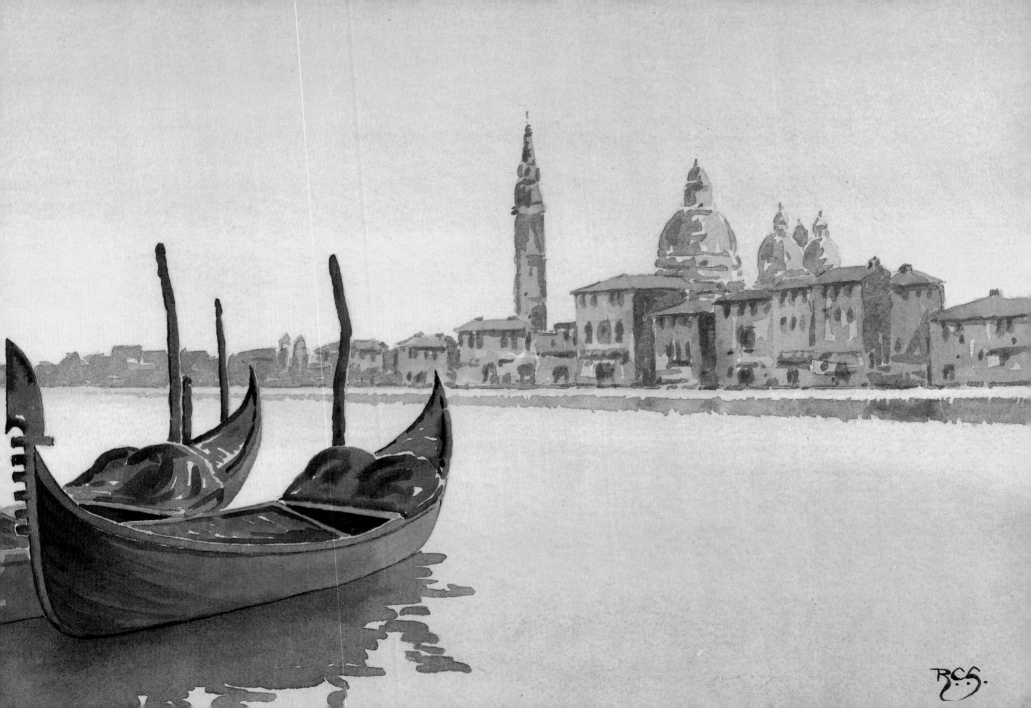

Cretan Fisherman

PALETTE
raw sienna
burnt sienna
light red
French ultramarine
Winsor blue
Payne's grey

PAPER
Arches 300lb
(640gsm) rough

BRUSHES
Two 1in (2.5cm) flats,
No.14 sable, No.12 and
No.10 Sceptre rounds

THE inner harbour at Ayios Nikolaos still boasts many solid old working craft, though the smart pleasure variety are gradually taking over. I made many a study of Cretan fishermen mending their nets, both in their boats and ashore, and this one, painted while I was sitting on the edge of the harbour wall, found favour with Spiro, the fisherman, and his cronies – he still has the original charcoal sketch.

The inner harbour is very deep – bottomless, according to local folklore – so there was little chance of recovering a perfectly good tube of French ultramarine which fell into the water. No matter – perhaps it will make that enchanted sea even bluer.

Boats viewed at this angle need careful drawing and I spent some time getting their subtle curves just right. The painting itself took less time than the sketch and the full washes dried quickly in the hot sun. The water was a pale variegated wash with French ultramarine and a touch of light red at the top merging softly into Winsor blue at the bottom, with many a chip of white paper left to suggest the sun catching the ripples. The nearer boat was mainly French ultramarine

Even the rusty bait tin had a part to play in this harbourside composition.

Resist the temptation to begin painting until you are happy with your sketch – colour never disguises faults!

with a little light red added, and the deck of the further boat was Winsor blue and raw sienna, with a few added rust stains of burnt sienna. The reflections were a deep greenish colour and for these I applied liquid washes of Payne's grey and raw sienna. I could have done with some masking fluid for the various ropes, but with none to hand, I had to paint carefully round them.

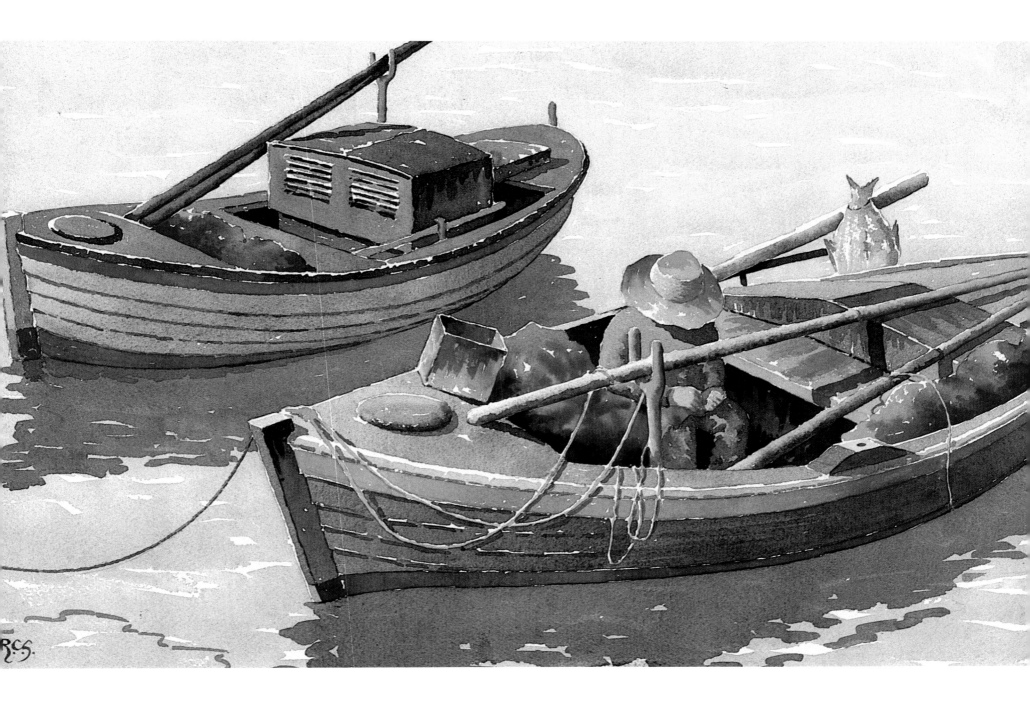

Quayside Reflections

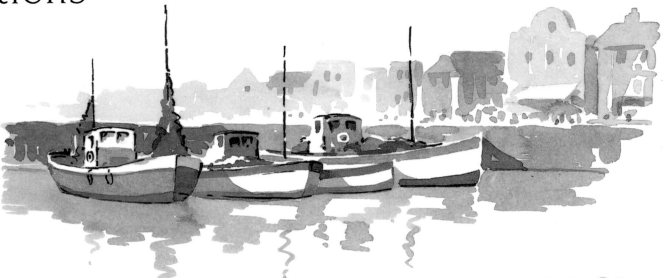

RENCH ports and fishing villages are usually rich sources of subject matter for the perceptive watercolourist. Moored boats and their reflections in the calm waters of an inner harbour, against a backdrop of quaint old quayside buildings, strike a chord in all of us and almost demand to be painted. The trouble is that the very complexity of the subject and the superabundance of detail often lead to over-complication and over-working, and that is where freshness and clarity begin to elude us. If we are to capture

In this painting the white of the untouched paper makes an important contribution to the whole.

PALETTE

raw sienna
burnt sienna
light red
French ultramarine
Winsor blue

PAPER

Arches 300lb
(640gsm) rough

BRUSHES

1in (2.5cm) flat,
No.14 sable, No.12,
No.10 Sceptre rounds

Let your painting show what it was about your subject that inspired you to paint it.

the true atmosphere and the salty flavour of the scene we must make up our minds to simplify drastically and concentrate on conveying the essential character of the subject.

The features that appealed to me most about this scene were the shining reflections of the moored boats and the way in which their glistening white hulls contrasted with the deeper tones of the harbour wall. It was clear that the water would have to be handled with bold, free brushstrokes if the desired effect was to be captured and that a

careful and precise approach would not do.

The colour-washed harbourside buildings needed equally bold treatment, but in softer pastel tones, while the crowds of holiday-makers might be effectively suggested by dabs of various colours. Having decided upon my viewpoint, I sketched in the boats and a few important construction lines on my watercolour paper and set to work to apply liquid, translucent washes and eschew detail, in the hope that I might capture something of the shine and movement of the scene.

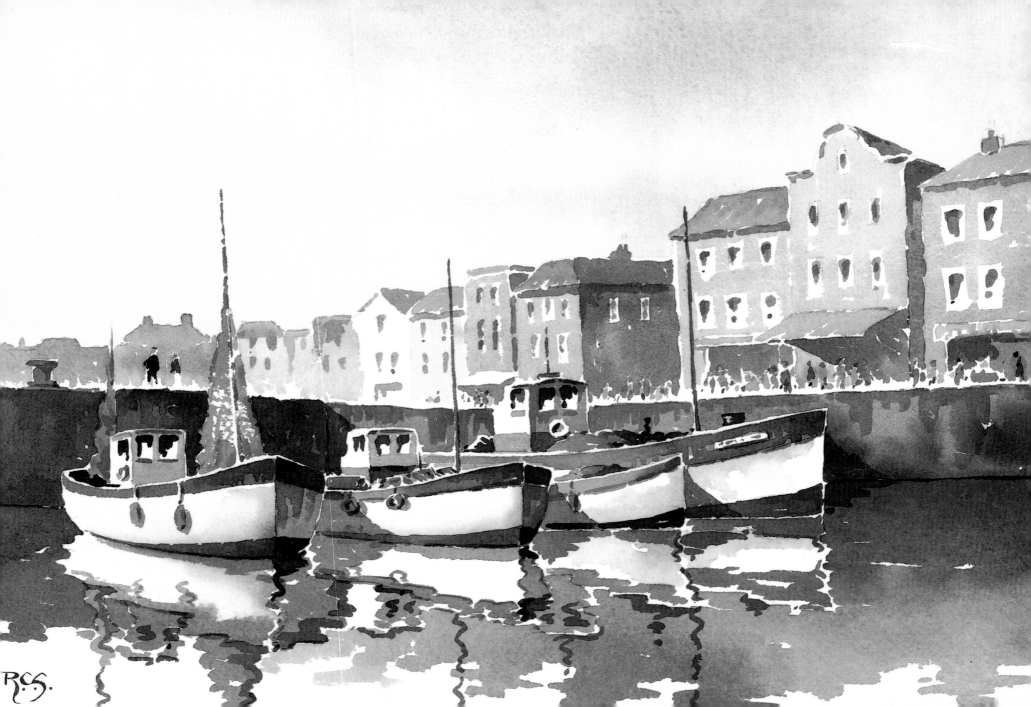

Honfleur Harbour

THE historic French port of Honfleur has long been a haunt of artists and it is not difficult to see why. The attractive harbourside buildings, the quaint old narrow streets and the assortment of boats at anchor in the smooth waters of the harbour combine to produce a wealth of fascinating subjects. This is one of my favourite vistas though, as my sketch book testifies, there were many more that I found equally appealing.

There were rather more boats in the harbour than I have indicated and I concentrated on just a few for the sake of simplicity. While I was sketching in the main construction lines on my watercolour paper, it became obvious that nearly all the tonal weight of the subject was on the left, so I put in the foreshortened shape of a sailing boat in the right foreground and this gave me the compositional balance I required.

I painted the cumulus clouds loosely and kept the lower sky comparatively light-toned

Here multi-coloured dabs of paint suggest crowds of people.

Rigging should not be painted too literally or a cat's cradle effect can easily result. Just an impression of the main lines is all that is required.

so that the buildings would register effectively against it. I made the most of the variety of colours in these buildings, but let my washes run together and merge in places so that the result would not look too precise. The crowds of people on the left are just multi-coloured dabs of paint. Once again, I looked for tonal contrast wherever it was to be found: the light boats against the dark harbour wall and the deeper-toned foreground boat against a stretch of shining water are just two examples.

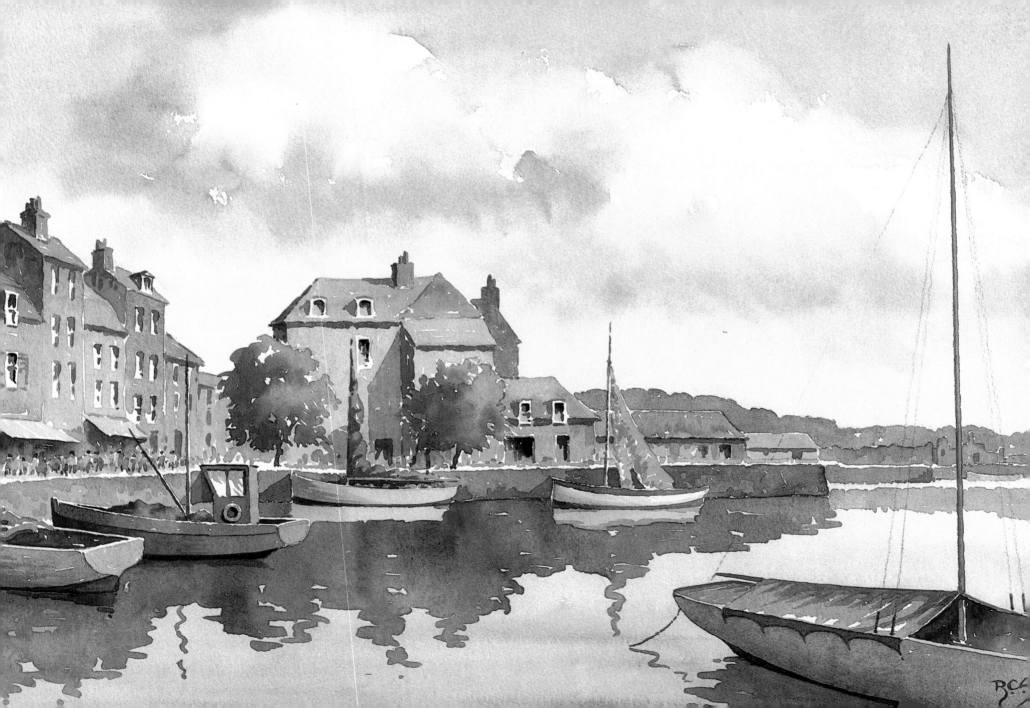

5 DRAMATIC LANDSCAPES

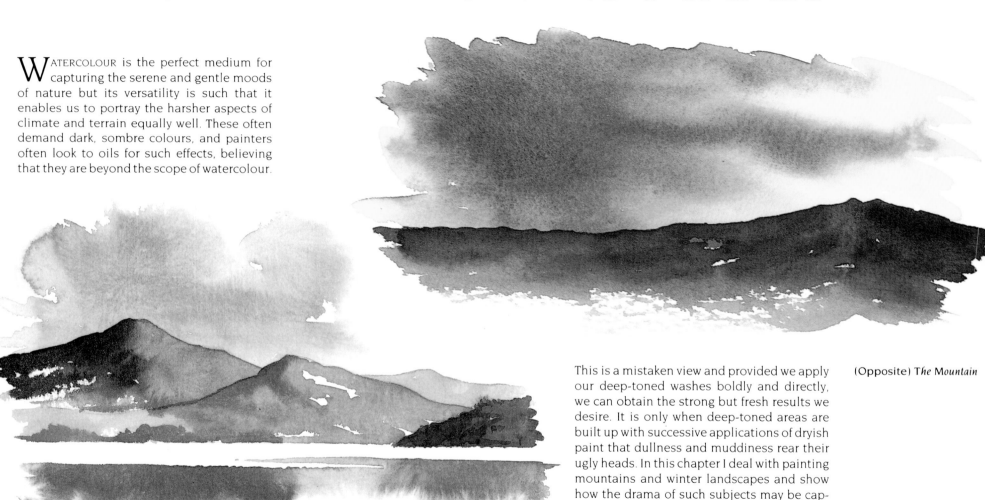

W̲ATERCOLOUR is the perfect medium for capturing the serene and gentle moods of nature but its versatility is such that it enables us to portray the harsher aspects of climate and terrain equally well. These often demand dark, sombre colours, and painters often look to oils for such effects, believing that they are beyond the scope of watercolour.

This is a mistaken view and provided we apply our deep-toned washes boldly and directly, we can obtain the strong but fresh results we desire. It is only when deep-toned areas are built up with successive applications of dryish paint that dullness and muddiness rear their ugly heads. In this chapter I deal with painting mountains and winter landscapes and show how the drama of such subjects may be captured by the imaginative handling of light and shade and of tonal contrast.

The preliminary sketches were all made in monochrome watercolour (ivory black).

(Opposite) *The Mountain*

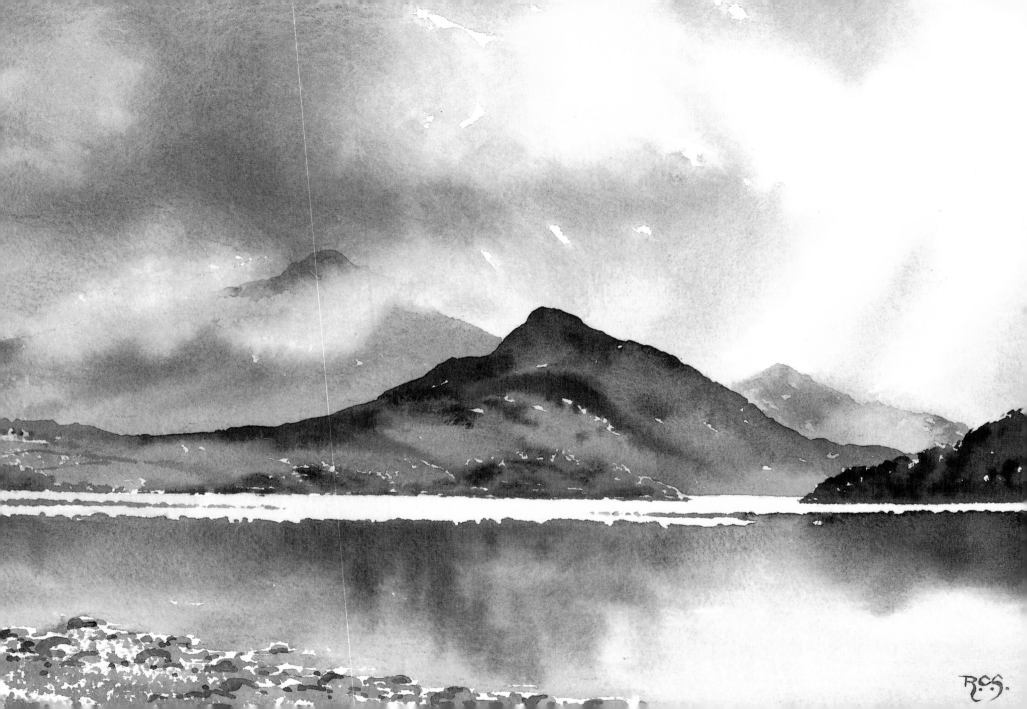

The Hillside

PALETTE

raw sienna
burnt sienna
light red
French ultramarine
Payne's grey

PAPER

Saunders Waterford
300lb (640gsm) Not

BRUSHES

Two 1in (2.5cm) flats,
No.14 sable, No.10 and
No.8 Sceptre rounds

LONELY Cumbrian farmhouses with solid, whitewashed walls and stone outbuildings, make delightful subjects as they nestle against their fringe of sheltering trees. This one appealed to me particularly, partly because of its dramatic tonal contrast with its sombre setting and partly because it formed part of a pleasing composition.

It was another day of heavy but broken cloud cover, and I made the most of a short spell when the sun burst through to light up the farmhouse and its surroundings. On days like this you have to freeze such a moment in your mind's eye and record it as quickly as possible, for the areas of light and shade are constantly changing.

In my first sketch the outhouses obscure the centre of the farmhouse – not a harmonious arrangement.

The final sketch.

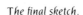

The rough track curved obligingly into the painting, carrying the eye towards the group of buildings, while the nearer hills on the left and even the rays of the sun perform a similar function. The buildings are, perhaps, rather strung out in a line for a perfect composition, and although my second sketch showed them to better advantage, the arrangement of the other components was less satisfactory. I determined to make the most of the strong tonal contrasts in the painting and to keep my brushwork loose and free.

In both rejected sketches, the track leads the eye right past the centre of interest – the farm buildings. In the third sketch it leads the eye directly to it.

The line of a rather too insistent road or track can be broken by placing a shadow across it.

Winter in the Countryside

A MANTLE of snow transforms the appearance of the countryside dramatically and has a way of upsetting our preconceived notions of tone values. The stark whiteness of the snow makes everything else look much darker by contrast and this applies not only to objects in the landscape such as buildings and trees, but also to the sky itself. The obvious way to make the snow appear to shine is to paint the sky several tones darker than normal and then treat everything else – except of course the snow – in a similar manner. This is what I did in my preliminary monochrome sketch and in the

PALETTE

raw sienna
burnt sienna
light red
French ultramarine
Payne's grey

PAPER

Arches 300lb
(640gsm) rough

BRUSHES

Two 1in (2.5cm) flats,
No.14 sable, No.10,
No.8 Sceptre rounds

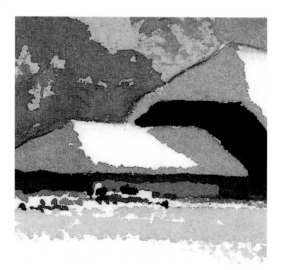

The white of the paper can effectively suggest snow.

finished painting, leaving the white of the paper to represent the snow.

Shadows in the snow take their colour from the sky, here a cool grey. On fine days, with clear skies, snow shadows can be startlingly blue, while in sunset conditions a wide variety of warm colours may be seen. The horizontal shadows in the foreground snow were suggested by drawing a large well-charged brush rapidly over the surface of the paper. Notice the depth of tone of the buildings and the exposed lines in the foreground ploughland which, incidentally, help to lead the eye into the painting. The trees are naturally somewhat paler because the broken washes have to represent the bare twigs and the sky between them.

Snow scenes are fun to do, and if you treat your tone values in the manner I have suggested, you will not find it difficult to produce bold and effective paintings.

Make your snow shine by painting everything else several tones darker than you otherwise would.

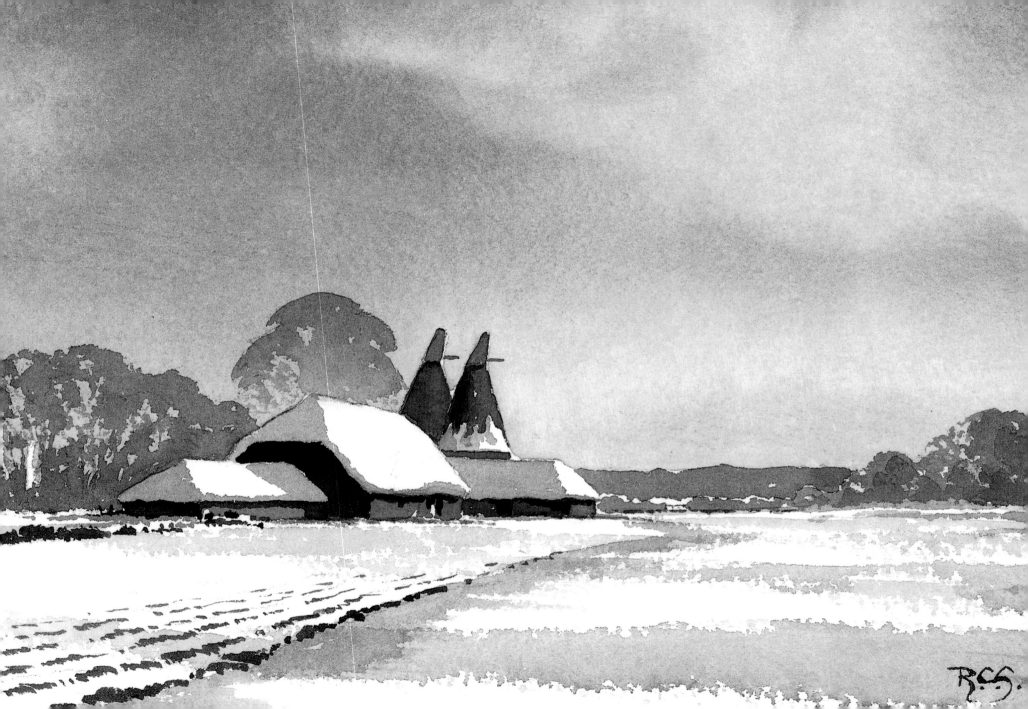

Lakeland Scene

WHEN I made my first sketch of this attractive scene, the light was coming from the right. I quickly realized there would be many more effective tonal contrasts if I 'possessed my soul in patience' and waited for the sun to move through 180 degrees. Needless to say, I found plenty of other subject matter to fill the time. This was the monochrome study I finally selected. It enabled me to work out my tone values without the complicating considerations of colour and to find tonal contrasts in every part of the scene. Paintings sometimes fail

PALETTE

raw sienna
burnt sienna
light red
French ultramarine
Winsor blue

PAPER

Arches 300lb
(640gsm) rough

BRUSHES

Two 1in (2.5cm) flats,
No.14 sable, No.10,
No.8 Sceptre rounds

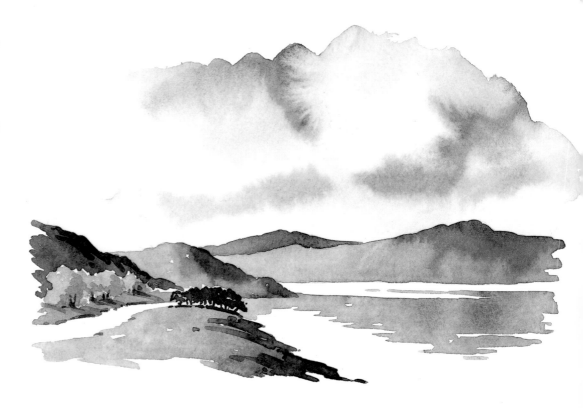

Remember to indicate shadow under a heavy cloud formation.

because adjacent features which should appear separate are painted so similar in tone that they seem to merge together. By concentrating on tone we can vary our values to prevent this happening.

Notice how the lines of the hills, the track, the shores of the lake and even the reflections seem to carry the eye into the heart of the scene. Notice, too, how in the finished painting, the deeply shadowed sides of the nearer hills contrast strongly with the sunlit areas behind and how the pale, warm green of the hill on the far side of the lake has both tonal and colour contrast with the deeper blue-grey of the line of distant mountain. Once again, the heaviest cloud shadow on the right helps to balance the deep tones of the hills on the left.

It pays to wait for the sun to move if this means the shadows will then provide better tonal contrasts and assist your composition.

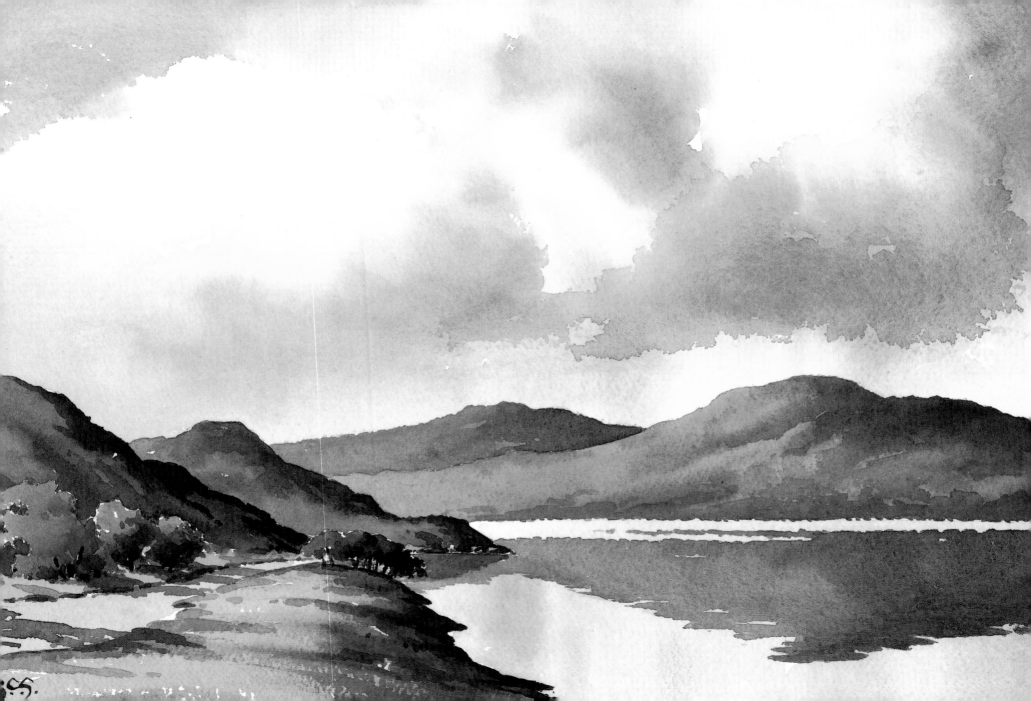

Winter Landscape

PALETTE

raw sienna
light red
French ultramarine

PAPER

Arches 300lb
(640gsm) rough

BRUSHES

1in (2.5cm) flat,
No.14 sable, No.10,
No.8 Sceptre rounds

I CONFESS this painting was not made on the spot but in the comfort of a warm studio, shortly after a trudge through the snow in sub-zero temperatures. Although the weather was bitterly cold, the colours were warm, as a late afternoon sun struggled to penetrate the mist.

The composition is a simple one, with the little river curving into the painting and being prevented by the right hand bank from carrying the eye out of it. I included a second pollarded willow in the finished painting and

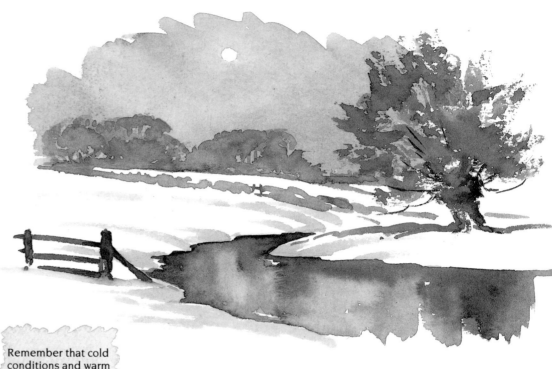

Remember that cold conditions and warm colours can coexist!

The warm colours of the sky are reflected in all parts of the painting.

devoted more space to the wintry sky. This was a warm wash of light red and French ultramarine merging softly into a light red and raw sienna halo round the sun. I used masking fluid for the sun itself and then softened the rather too hard edge with a moist brush. I used a very pale wash of light red and raw sienna over the snow, adding some warm grey shading wet in wet and some stronger hard edged shadows when

the initial wash had dried.

The distant trees and hedges were put in with the side of a No.10 brush dipped in another wash of light red and French ultramarine. The nearer willows were painted more strongly with various combinations of raw sienna, light red and French ultramarine. The little river went in last, its deep tones reflecting the sombre sky and the dark willows.

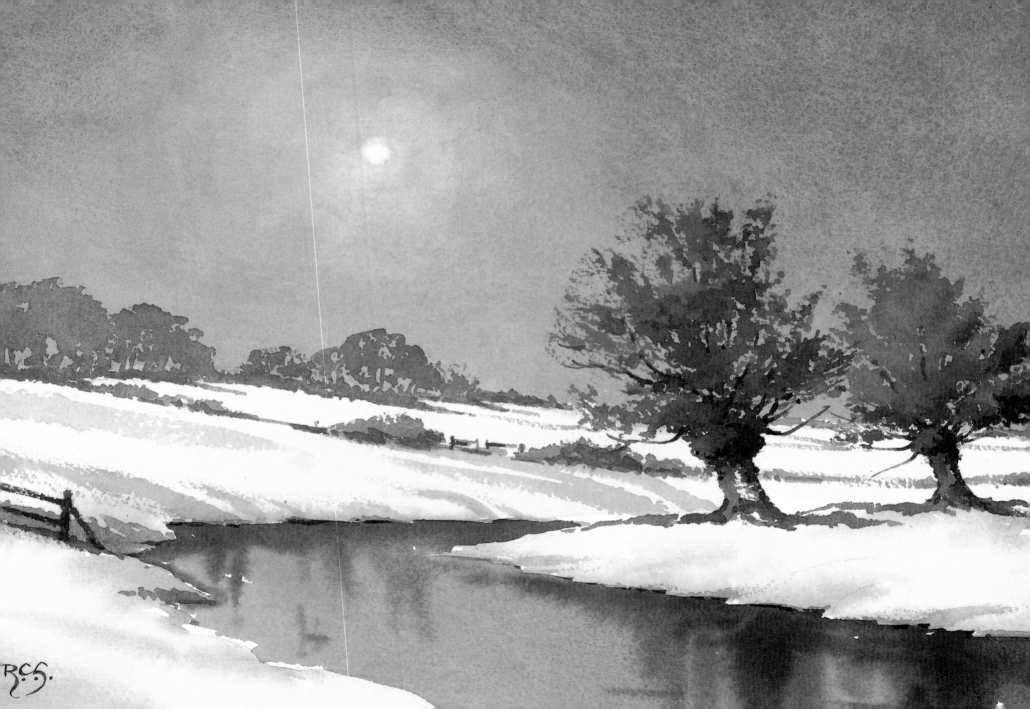

Early Snowfall

Always give thought to directing the eye of the beholder into the heart of your painting.

A FARM gate in a line of hedge serves the useful purpose of directing the eye to what lies beyond and here the suggestion of a track leading towards it serves much the same purpose. The gate also constitutes a focal point in a simple composition consisting of just fields, trees, hedges and distant hills.

In the finished painting the snow is simply the untouched Arches watercolour paper and its slightly creamy hue is here preferable to dead white, given the warm colour of the sky above the horizon. The shadows on the snow are broken washes of a pale French ultramarine and light red mixture and reflect a similar colour in the cloud shadows above. The same wash also served for the line of distant hills.

I painted the trees and hedges in very deep tones to contrast with the snow, using both raw and burnt sienna in conjunction with Payne's grey to capture the warm and

The deep tones of gate, hedge and trees help to make the snow shine by contrast.

cool colours of the foliage. For the shadows, the trunks and branches I added a strong mix of French ultramarine and light red. I used the same deep colour for the farm gate, which I added with quick strokes of a No.8 brush, this rather rough treatment being preferable, in the context of this painting, to something more precise.

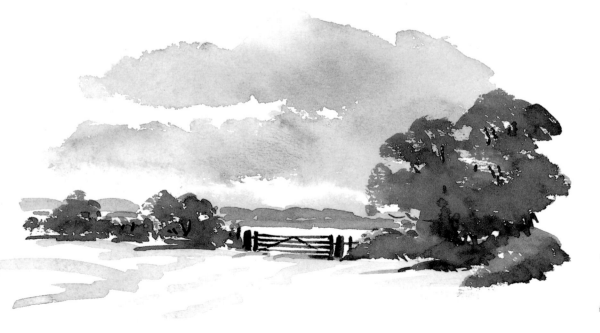

PALETTE

raw sienna
burnt sienna
light red
French ultramarine
Winsor blue
Payne's grey

PAPER

Arches 300lb
(640gsm) rough

BRUSHES

1in (2.5cm) flat,
No.14 sable, No.10,
No.8 Sceptre rounds

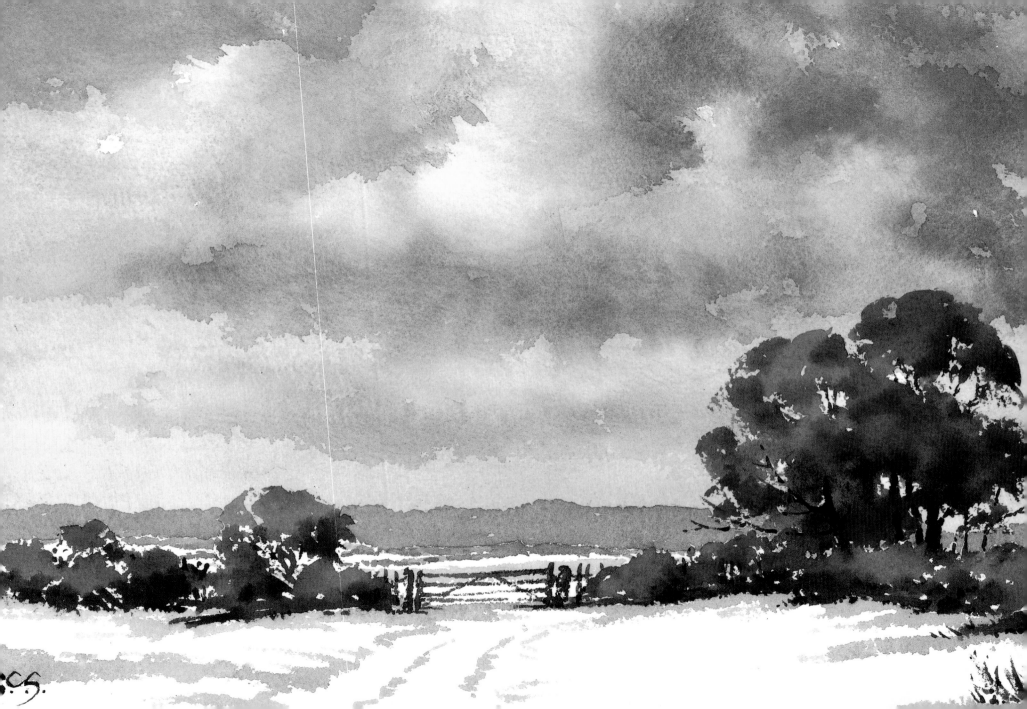

Highland Village

Part of this attractive village is sited on a spit of land that juts out into a sea loch to make an attractive feature against its backdrop of mountains. As I made my initial sketch a fitful sun was catching the walls of the houses and made them stand out boldly against the dark shoulder of hill. The light soon changed and for my subsequent sketches the buildings were in cloud shadow and were rather lost against their sombre background. I therefore decided to base my painting on sketch number one, with its more telling tonal contrasts.

My first objective was to capture something of the lively cloud formation by applying bold, liquid washes and allowing them to merge here and there. The warm tone just above the horizon was pale raw sienna and the cloud shadows were French ultramarine and light red with a hint of Payne's grey in

The sunlit buildings register strongly against the sombre background.

places. The blue-grey of the distant mountains was a single wash of French ultramarine with a little light red and I added raw and burnt sienna for the warmer passages of the nearer hills. I kept the tone of the smooth water as light as possible to enable it to shine against the deeper tones of the surrounding land forms.

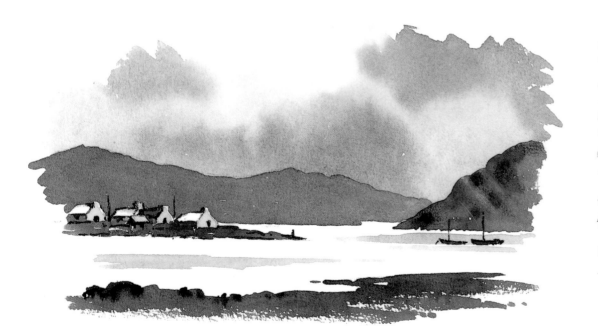

PALETTE

raw sienna
burnt sienna
light red
French ultramarine
Payne's grey

PAPER

Arches 300lb
(640gsm) rough

BRUSHES

Two 1 in (2.5cm) flats,
No.14 sable, No.10,
No.8 Sceptre rounds

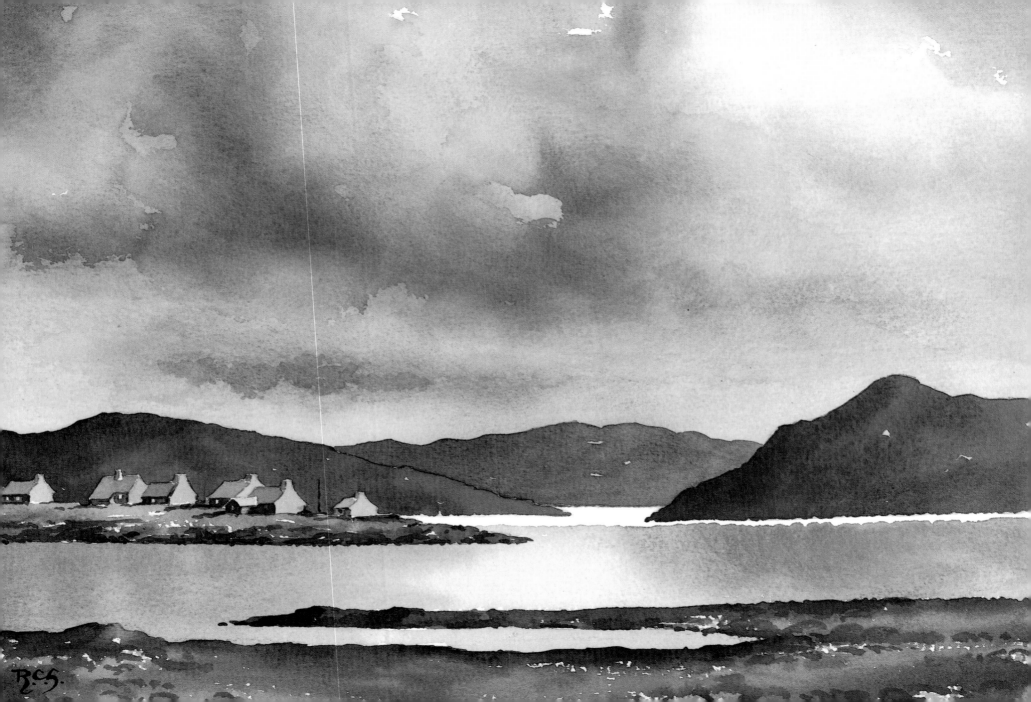

The Hamlet in Winter

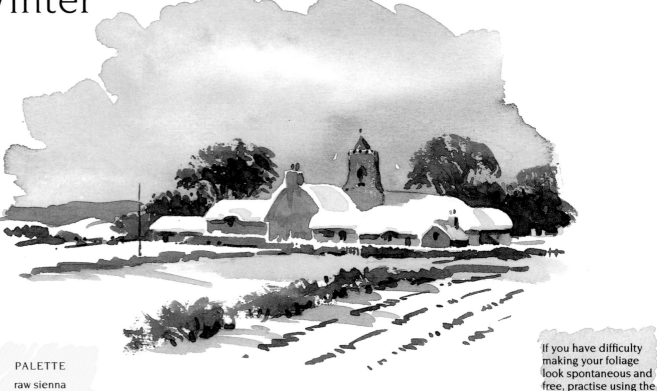

Here is another winter scene in which the whiteness of the snow is emphasized by the deep tones of the sky and the still deeper tones of the other features in the landscape. Once again, the shadows in the snow take their colour from the blue-grey of the lowering sky which was mainly Payne's grey with a French ultramarine and light red mixture for the deeper shadows, but a hint of sunlight to explain the shine on the snow.

The lines of the distant wooded hills, the hedges and the furrows in the foreground

Strong tonal contrasts help to create effective snowscapes.

120

PALETTE

raw sienna
burnt sienna
light red
French ultramarine
Payne's grey

PAPER

Arches 300lb
(640gsm) rough

BRUSHES

1in (2.5cm) flat,
No.14 sable, No.10,
No.8 Sceptre rounds

If you have difficulty making your foliage look spontaneous and free, practise using the side of your brush on rough paper.

field all direct the eye towards the cottages clustering round the little church, which form the focal point of the painting. The dark tree on the left provides some compositional balance.

I took full advantage of the roughness of the paper to obtain the ragged outlines of the trees and hedges by dragging the side of a loaded No.10 brush rapidly across the surface – a quick and effective technique which not only saves time but produces a spontaneous and unlaboured result. The deep tones of the trees were mainly a mixture of light red and French ultramarine and this also served for the shadows in the burnt sienna of the hedges. Only the little hamlet is painted with any precision, as befits a centre of interest.

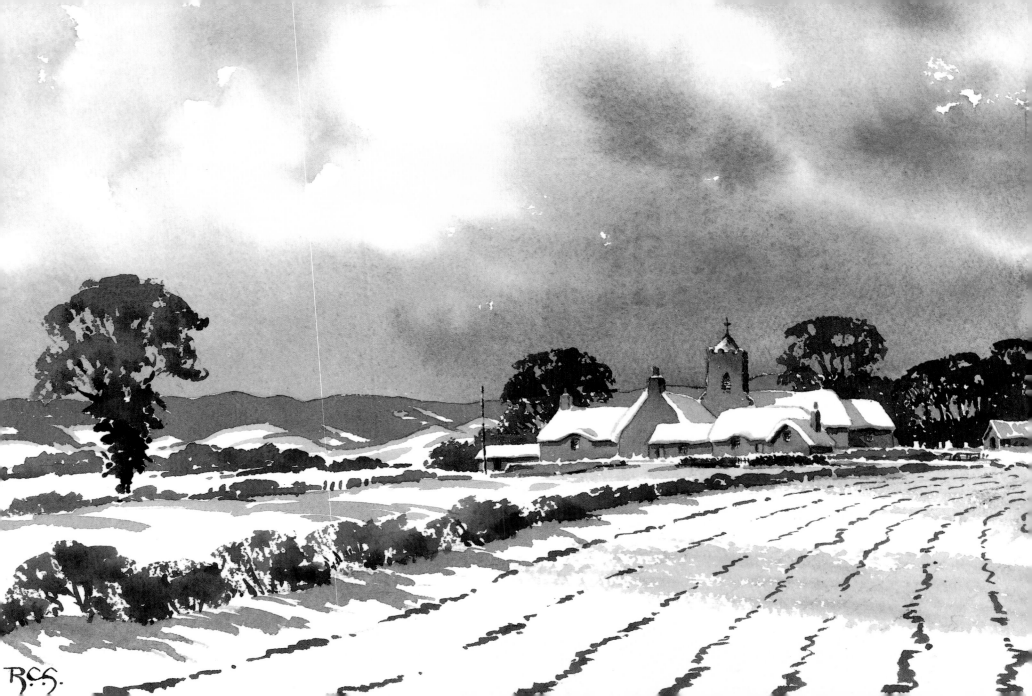

Highland Cottage

I ORIGINALLY planned to balance this single storey cottage with the mountain peak but soon found I could only do so from a position where the building appeared head on. As I preferred an oblique angle, from which both sunlit and shadowed elevations were visible, I chose this sketch and mentally transported a clump of trees a short distance to provide, with their deep reflections in the stretch of water below, useful tonal balance. The smooth water also provides a calm place for

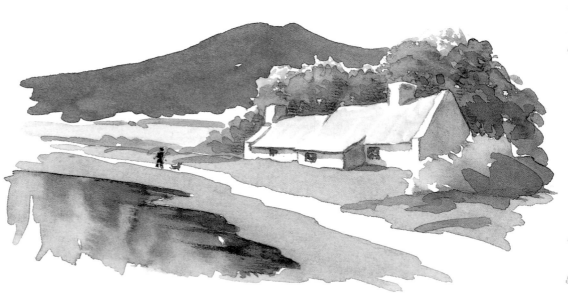

The warm colours of the autumnal trees contrast with the cool greys of the mountains.

the eye to come to rest. The track carries the viewer into the painting to the man and his dog who provide a focal point, and the trees and bushes on the left act as a stop, to prevent the track carrying the eye off the painting.

I established the lively cumulo-nimbus sky first and added a second wash of grey to deepen the cloud shadow. This provided

some hard edges where I wanted them but I blended the upper parts with pure water into the initial wash. I kept the area of sky above the horizon very pale to contrast with the dark shoulder of mountain, while the warm tones of the trees behind the cottage provide strong colour contrast with the cool blue-grey of their background.

PALETTE

raw sienna
burnt sienna
light red
French ultramarine
Winsor blue
Payne's grey

PAPER

Arches 300lb
(640gsm) rough

BRUSHES

Two 1in (2.5cm) flats,
No.14 sable, No.10 and
No.8 Sceptre rounds

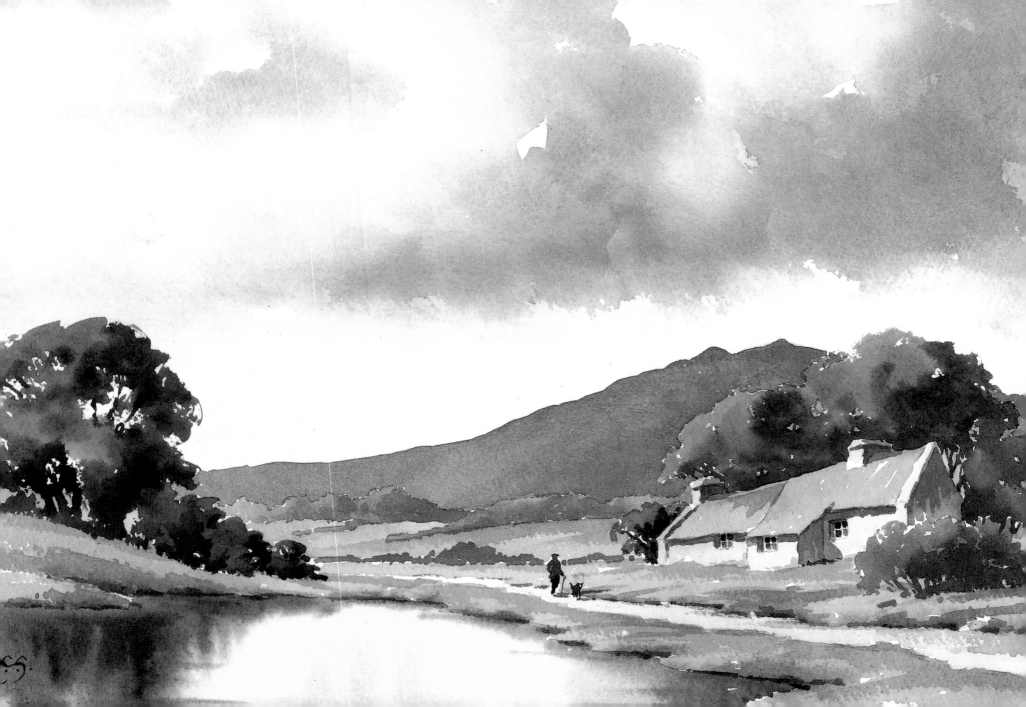

Snowscape

I AM not sure that this rather peaceful winter scene really qualifies for inclusion in a chapter headed 'Dramatic Landscapes'! Be that as it may, it illustrates another method of tackling a snowscape, with gentle colours and only the trunks of the trees to provide really dark accents.

The Arches watercolour paper, with its slightly creamy hue, served well for the snow in the soft afternoon light. I prepared a pale wash of French ultramarine and light red for the snow shadows which took their colour from the warm grey of the sky, and used the same combination for the lines of distant woodland and hedge. The raw sienna and light red used in the nearer trees, being warm colours, helped to bring them forward.

In the sketch, the deep-toned clump of dead reeds is rather too central for comfort. In my finished painting I have played it down so that it no longer appears as a dominant feature in the centre of the painting.

I used just three colours, which helps the painting to 'hang together'.

Make sure the horizon line of your water is lying flat before putting brush to paper!

The trunks and branches of trees often appear deep-toned in winter settings.

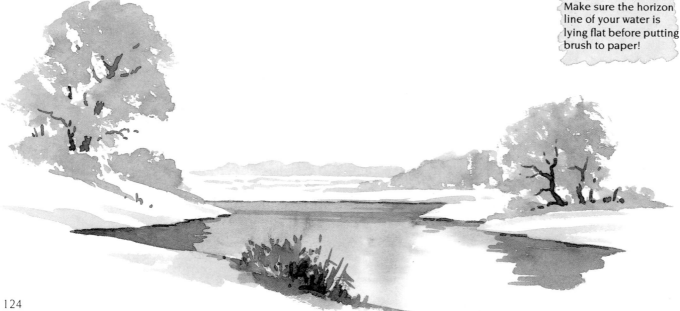

124

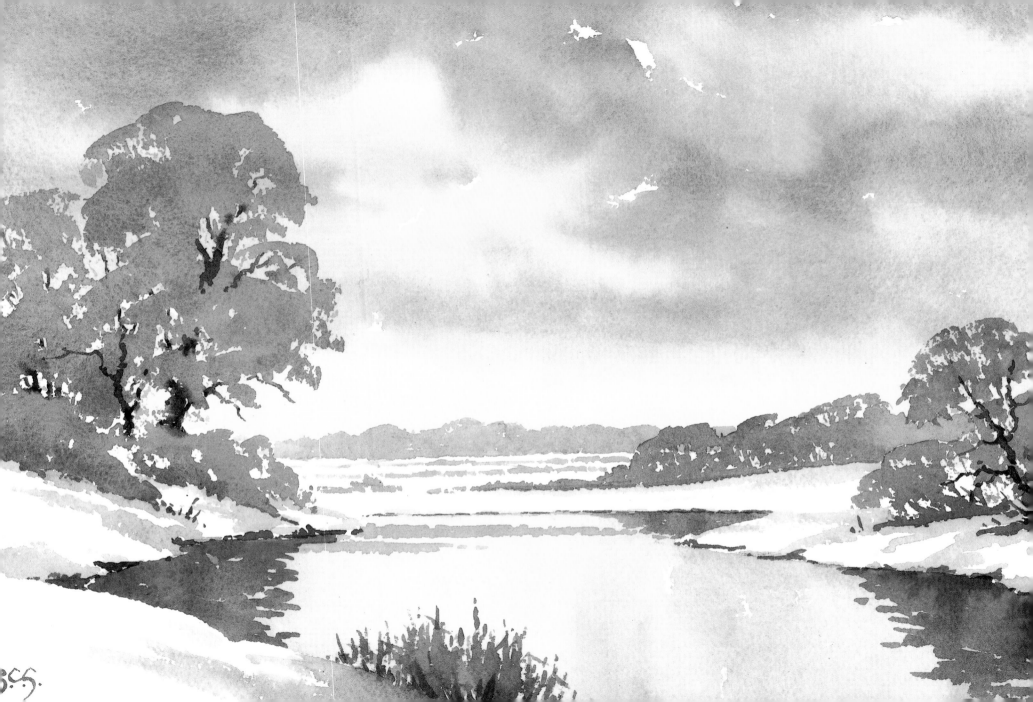

Lakeside Fortress

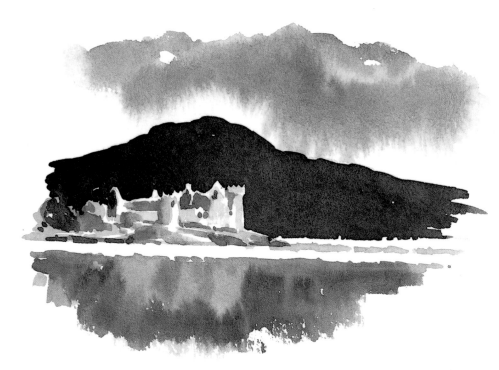

IF THE claim of the painting on the previous page to be described as 'dramatic' was questionable, there can be no doubt about this one! The grim pile of this old castle occupies a commanding position on the shores of the lake and is here seen against a deep-toned mountain mass which appears still darker against a patch of luminous sky. The narrow band of disturbed water catches this brilliant light while the smoother water below softly reflects the deep tones of mountain and castle. Everywhere there is

PALETTE

raw sienna
burnt sienna
light red
French ultramarine
Payne's grey

PAPER

Arches 300lb
(640gsm) rough

BRUSHES

Two 1in (2.5cm) flats,
No.14 sable, No.10,
No.8 Sceptre rounds

Washes, however deep-toned, can still look fresh if correctly applied.

intense tonal contrast and it is this that gives the painting its dramatic impact.

I applied a wash of palest raw sienna to the whole of the sky and then dropped in, wet in wet, two stronger and less liquid washes, one of French ultramarine and light red and another of Payne's grey, for the cloud shadows. Because my board was at an angle – about fifteen degrees from the horizontal – these washes ran down the paper a little to suggest falling rain. I prepared three very strong washes for the mountain, the first of raw sienna and Payne's grey, the second of Payne's grey alone and the third of French

ultramarine and light red. I protected the water below with a strip of masking tape and the castle with masking fluid and applied the washes as quickly and boldly as I could. Once they had dried – and this took some time because of the richness of the paint – I painted in the castle, leaving a little white here and there to suggest the light catching the tops of the battlements and this helped them to stand out against their dark background. I applied a wash of pale raw sienna to the smooth water and paler versions of the previous washes wet in wet, for the soft reflections, using quick, vertical brushstrokes.

Do not be afraid to use strong colour when the subject demands it, but apply it quickly and boldly in one full wash to avoid the danger of a muddy result.

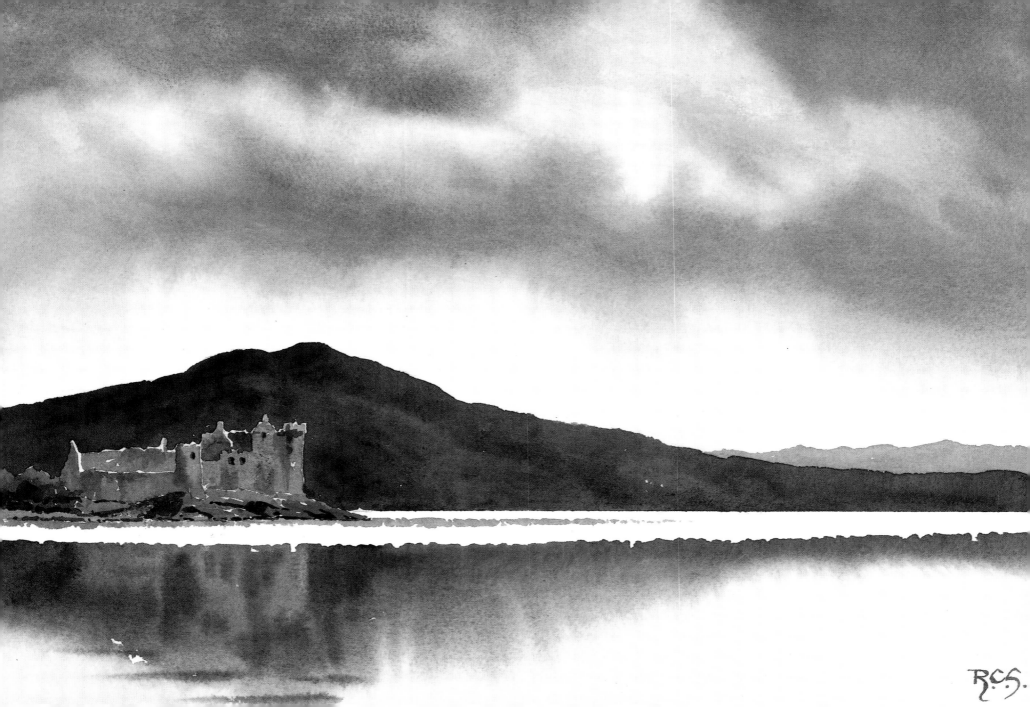

INDEX